1000SIGNS

1000 SIGNS is a project by COLORS Magazine

To stay informed about upcoming TASCHEN titles,
please request our magazine at www.taschen.com/magazine
or write to TASCHEN, Hohenzollernring 53, D-50672 Cologne,
Germany; contact@taschen.com; Fax: +49-221-254919.
We will be happy to send you a free copy of our magazine,
which is filled with information about all of our books.

© 2009 TASCHEN GmbH
Hohenzollernring 53, D–50672 Köln
www.taschen.com

© 2009 COLORS Magazine s.r.l.
Via Villa Minelli 1, 31050 Ponzano Veneto (TV)
www.colorsmagazine.com

Editors Carlos Mustienes and Thomas Hilland
Art director Marco Callegari
Associate art director Isotta Dardilli
Co editor Giuliana Rando
Associate editors Samantha Bartoletti and Grégoire Basdevant
Editorial coordination Thierry Nebois
Text editor Tom Ridgway
German editor Karen Gerhards
French editor Isabelle Baraton

Editorial director Renzo di Renzo

Cover design Sense/Net, Andy Disl and Birgit Eichwede, Cologne
Production Marco Callegari
Lithography Sartori Group S.r.l.
Thank you Bruno Ceschel, Giovanna Dunmall, Sara Gaiotto,
Rose George, Michele Lunardi, Michael Medelin,
Loris Pasetto, Renzo Saccaro, Claudio Sartori,
Janine Stephen, Suzanne Wales, Fiona Wilson.

Printed in China
ISBN 978–3–8365–1001–1

COLORS

1000SIGNS

TASCHEN

HONG KONG KÖLN LONDON LOS ANGELES MADRID PARIS TOKYO

Contents
Inhalt
Sommaire

163
Miscellaneous
Verschiedenes
En vrac

181
Danger
Gefahr
Danger

215
Weapons
Waffen
Armes

231
Toilets
Toiletten
Toilettes

259
No!
Nein!
Non!

301
Work
Arbeit
Travail

The Ancient Romans used road signs to show the distance to Rome from the different parts of their empire. And until the twentieth century signs didn't really change: They just pointed the way and showed you how far to go. Then cars arrived, speeds went up and suddenly signs were essential for everyone's safety. Drivers had to know where to go, what dangers lay ahead, what other road users were going to do—and they had to know quickly and simply. So circles, triangles, rectangles and octagons decorated with symbols began to sprout up. When cars spread around the world road signs became the only truly international language, created so that anyone from anywhere could understand. While even country-specific signs (you don't see many "koala bear crossing" signs in Norway) are generally easy to understand, that doesn't mean that you won't sometimes need some help. We'd like to think of this book as a road signs language guide, preparation for the next time you hit the road. By the time you've finished reading, you'll know exactly how to read any dangers you might face, whether it's a kangaroo or a landmine.

An den alten Römerstraßen gaben Meilensteine die Entfernung zur Hauptstadt des Imperiums an. Und an diesem Prinzip änderte sich bis zum 20. Jahrhundert nichts: Wegweiser beschränkten sich darauf, Richtung und Entfernung anzuzeigen. Dann kam mit dem Auto die Geschwindigkeit, und Schilder wurden für die Sicherheit der Verkehrsteilnehmer unverzichtbar. Autofahrer brauchten möglichst schnell verständliche Informationen über die Richtung, in die sie fuhren, eventuelle Gefahren und die Absichten der anderen Verkehrsteilnehmer. Bald waren die Straßen mit kreisförmigen, drei-, vier- und achteckigen Schildern mit Symbolen übersät. Verkehrszeichen wurden mit der Verbreitung von Autos auf der ganzen Welt zur allgemeinverständlichen künstlichen Sprache. Selbst wenn sogar landesspezifische Zeichen (in Norwegen sind Schilder, die vor die Straße überquerenden Koalas warnen, eher

selten) im Normalfall begreiflich sind, kann man dennoch manchmal Hilfe gebrauchen. Dieses Buch soll auf der nächsten Reise als Wörterbuch für Schilder dienen. Der aufmerksame Leser und Betrachter wird am Ende des Buches genau wissen, ob die Gefahr auf der Straße von einem Känguru oder einer Landmine droht.

Les Romains utilisaient déjà des panneaux de signalisation pour indiquer la distance à laquelle se trouvait Rome des différents points de leur empire. Au reste, de l'Antiquité au 20e siècle, bien peu de choses changèrent en matière de signalisation : les poteaux indicateurs se contentaient de pointer dans une direction et d'indiquer la distance à parcourir. Puis les automobiles déboulèrent dans le paysage, prirent de la vitesse et, soudain, les panneaux devinrent essentiels à la sécurité de chacun. Les conducteurs devaient non seulement savoir où aller, mais aussi être informés des dangers qui les attendaient, de ce qu'allaient faire les autres usagers de la route, le tout de façon claire et rapide. C'est ainsi que cercles, triangles, rectangles et octogones décorés de symboles commencèrent à pousser et se multiplier sur les routes. Lorsque la voiture se répandit dans le monde, les panneaux suivirent, à tel point qu'ils représentent aujourd'hui le seul langage réellement international, conçu pour être compris par n'importe quel individu en n'importe quel lieu. Cependant, il existe quelques panneaux spécifiques à tel ou tel pays (on ne croise guère de panneau « attention, traversée de koalas » en Norvège) et, s'ils sont en général faciles à déchiffrer, il n'est pas exclu que vous ayez parfois besoin d'aide. Notre ambition a été de faire de ce livre un guide du langage de la signalétique routière, pour vous permettre de réviser en prévision de votre prochaine escapade. Lisez-le jusqu'au bout, et aucun danger de la route ne vous prendra plus au dépourvu, ni kangourou ni mine antipersonnel – pour peu, bien sûr, qu'ils soient signalés.

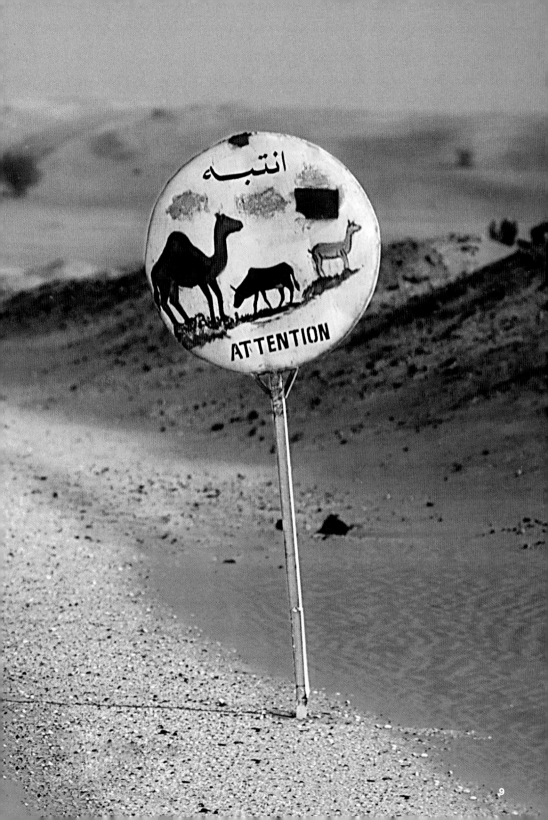

11
Animals
Tiere
Animaux

Roadkill
Plattgefahren
Accidentés de la route

You are a tortoise based in, say, southern Lithuania. All year long, you've been looking forward to the mating season. Your species has been returning to the same breeding grounds for the last 50,000 years, so it's sort of a tradition. As you set out this year, however, you run into an unexpected obstacle—a brand new highway. You've never crossed one before, and you're a little apprehensive. What should you do?

Before you decide to cross the road, here are some statistics you should know. US highways kill six times more deer each year than hunters do. In the UK, some 100,000 rabbits, 100,000 hedgehogs, 47,000 badgers and 5,000 barn owls become road casualties annually, and an estimated 30 percent of the amphibian population (including over a million toads) is flattened.

These figures might sound a little discouraging, but before you turn around and go home, there's another argument to consider. The mating season is very important for you tortoises. A disrupted reproductive cycle can lead a species toward extinction. And with an estimated 20,000 species going extinct each year, your fellow tortoises are counting on you.

So maybe it's best to cross the road and take your chances. After all, highways are now a permanent feature of the landscape. There are over 22 million kilometers of road on the planet (enough to stretch to the moon and back 28 times), and more are built every day. Today's highways may even be influencing animal evolution. According to some sources, a new generation of British hedgehogs is genetically disposed to flee from oncoming cars, rather than just curling up in a ball (the traditional hedgehog response). In Venezuela, green iguanas have even integrated the highway into their mating rites: When rival males fight for a mate, the loser must cross the road and start a new life on the other side.

So never mind that tortoises have been around for 200 million years. Highways are here for good. If your species intends to survive, you'll just have to learn to look both ways before you cross.

Stell dir vor, du bist eine Schildkröte in Südlitauen und freust dich schon das ganze Jahr über auf die Paarungszeit. Deine Spezies kehrt seit 50 000 Jahren immer wieder an dieselbe Brutstätte zurück, die Reise dorthin hat also Tradition. In diesem Jahr jedoch stößt du auf ein unerwartetes Hindernis – eine neue Autobahn. Da du noch nie eine überquert hast, bist du ein bisschen ängstlich. Was tun?

Bevor du dich anschickst, sie zu überqueren, solltest du dich mit einigen Statistiken vertraut machen. In den USA sterben in jedem Jahr sechsmal mehr Rehe auf den Autobahnen als durch die Kugeln von Jägern. In Großbritannien sind jährlich 100 000 Kaninchen, 100 000 Igel, 47 000 Dachse und 5000 Schleiereulen als Verkehrsopfer zu beklagen, ganz zu schweigen von schätzungsweise 30% aller Amphibien – darunter über 1 Million Kröten –, die platt gefahren werden.

Das klingt nicht gerade ermutigend, aber bevor du umdrehst und dich auf den Heimweg machst, solltest du Folgendes bedenken: Die Paarungszeit ist für euch Schildkröten von größter Bedeutung. Ein unterbrochener Fortpflanzungzyklus kann das Aussterben einer Spezies nach sich ziehen. Da Schätzungen zufolge Jahr für Jahr etwa 20 000 Arten aussterben, zählen deine Mitschildkröten auf dich. Deshalb solltest du vielleicht doch die Straße überqueren und es einfach mal drauf ankommen lassen. Autobahnen gehören heute eben zur Landschaft. Unseren Plane-

ten umspannen Straßen von 22 Millionen km Länge (das ist 28-mal die Strecke von der Erde bis zum Mond und zurück), und die Erde wird kräftig weiter zugepflastert. Autobahnen werden für Tiere mitunter sogar zum Evolutionsfaktor. Es heißt, britische Igel sollen inzwischen genetisch so disponiert sein, dass sie vor herannahenden Fahrzeugen die Flucht ergreifen anstatt sich – wie es der traditionellen Verhaltensweise entspräche – einzuigeln. Die Grünen Leguane in Venezuela haben Autobahnen bereits in ihre Paarungsriten aufgenommen: Wenn rivalisierende Männchen um ein Weibchen kämpfen, muss der Verlierer die Straße überqueren und sich auf der anderen Seite ein neues Leben aufbauen. Also Schluss mit dem Argument, dass Schildkröten schon seit 200 Millionen Jahren existieren. Mit den Autobahnen werdet ihr euch abfinden müssen. Wenn ihr als Spezies überleben wollt, müsst ihr lernen, nach links und rechts zu schauen, bevor ihr die Straße überquert.

Vous êtes une tortue originaire, disons, de Lituanie méridionale. Toute l'année, vous avez attendu avec impatience la saison des amours. Depuis 50 000 ans, vos congénères retournent sans faillir sur les mêmes lieux pour s'accoupler. Une tradition, si l'on peut dire. Vous vous mettez donc en route, cette année encore, et voilà que, soudain, vous vous heurtez à un obstacle inattendu : une autoroute flambant neuve. Une première pour vous et vous ressentez une certaine appréhension. Comment faire ?

Avant d'entreprendre la grande traversée, voici quelques statistiques qu'il vaut mieux connaître. Chaque année, les autoroutes américaines tuent six fois plus de cerfs que les chasseurs. Au Royaume-Uni, quelque 100 000 lapins, 100 000 hérissons, 47 000 blaireaux et 5 000 chouettes sont victimes d'accidents de la route. Selon les estimations, 30 % des amphibiens (dont plus de un million de crapauds) finiraient en galette sur le bitume.

Bien sûr, ces données ont de quoi vous décourager mais, avant de rebrousser chemin, il est un autre argument à prendre en considération. Vous autres tortues n'ignorez pas l'importance de la saison des amours. Que les cycles de reproduction s'interrompent et c'est l'extinction. Sachant que 20 000 espèces (si l'on en croit les estimations) disparaissent chaque année, imaginez à quel point vos congénères comptent sur vous.

Tout compte fait, mieux vaut peut-être tenter le tout pour le tout. En fin de compte, les autoroutes font désormais partie du paysage. À l'heure actuelle, plus de 22 millions de km de routes sillonnent la planète (de quoi couvrir 28 allers-retours entre la Terre et la Lune), et il s'en construit un peu plus chaque jour. Au reste, il est même possible que l'autoroute moderne ait une influence sur l'évolution des espèces animales. Il semblerait ainsi qu'une nouvelle génération de hérissons ait fait son apparition au Royaume-Uni, génétiquement prédisposée à fuir devant une voiture au lieu de se rouler en boule (ce qui est la réaction habituelle de ces animaux). Les iguanes verts du Venezuela ont même intégré l'autoroute dans leurs rituels amoureux : quand des mâles rivaux se disputent une femelle, le perdant est contraint de traverser la route et de refaire sa vie de l'autre côté.

Peu importe donc que les tortues aient été là les premières, qu'elles existent depuis quelque 200 millions d'années – désormais, autant s'y faire : les autoroutes sont là pour longtemps. Si votre espèce a l'intention de survivre, il lui faudra apprendre à regarder à droite et à gauche avant de traverser.

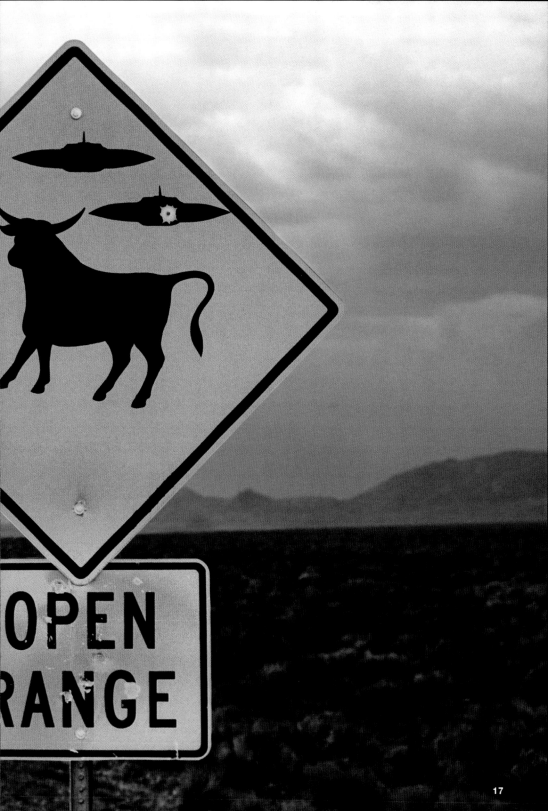

Mosquito Crossing
Mückenoffensive
La chasse aux moustiques

You can't feel the feet of a female mosquito on your skin—but she has no trouble sensing where your blood capillaries are. Every day, 2,700 children die from the malaria, which is transmitted by mosquitoes and kills more people than cancer. There is no vaccine for malaria: use repellents, suitable clothaing and anti-malarial drugs. It is difficult to treat, but one of the most effective methods of prevention is simple—an insecticide-treated mosquito net. In Tanzania, a four-year program to promote the use of nets cut malaria deaths by 80 percent. Malaria-free Finland used to deal with these insects in another way. The country was home to a Mosquito Killing Contest, which sadly—and despite being a perfect tourist trap—has now been disbanded. That does, however, leave 1995's winner as the current champion: All rise for Harri Pellonpa from Finland. He killed 21 in 3 minutes at the contest in Lapland, using nothing but his bare hands and some sharp reflexes.

Du spürst es nicht einmal, wenn sich ein Mückenweibchen auf deinem nackten Arm niederlässt, während die Mücke sogar die winzigsten Blutgefäße mühelos ausfindig macht. 2700 Kinder sterben täglich an Malaria, einer Krankheit, die von Mücken übertragen wird und mehr Menschen umbringt als Krebs. Gegen Malaria gibt es keinen Impfstoff, und die Krankheit ist schwer zu behandeln. Deine einzige Chance besteht in der Vorbeugung: Mückenabwehrmittel, schützende Kleidung und Malaria-Prophylaxe, vor allem aber mit Mückenspray imprägnierte Moskitonetze sind wirksame Mittel zur Malariabekämpfung. In Tansania verringerte sich die Sterberate durch die Krankheit nach einer vierjährigen Kampagne für Moskitonetze um 80%. Im malariafreien Finnland wird der Mückenplage auf andere Weise der Garaus gemacht, nämlich bei einer landesweiten Meisterschaft im Mücken-Erschlagen. Obwohl er als wahre Touristenattraktion galt, wurde der Wettkampf leider abgeschafft. Dadurch wurde der Sieger von 1995 zum unanfechtbaren Champion seiner Disziplin: Der Finne Harri Pellonpa tötete bei dem in Lappland ausgetragenen Wettbewerb innnerhalb von drei Minuten 21 Mücken – mit bloßen Händen und dank ausgezeichneter Reflexe.

Si vous ne sentez pas les pattes d'une femelle moustique sur votre peau, elle, en revanche, n'a aucun mal à sentir et repérer vos vaisseaux capillaires. Chaque jour, 2 700 enfants meurent du paludisme, maladie transmise par les moustiques et qui fait plus de morts que le cancer. Il n'existe à ce jour aucun vaccin contre ce mal. Les seuls recours restent donc les produits antimoustiques, les médicaments prophylactiques et des vêtements suffisamment couvrants. Les personnes atteintes étant difficiles à traiter, mieux vaut miser sur la prévention. Or, en la matière, les méthodes les plus simples s'avèrent être les meilleures : rien de tel qu'une bonne vieille moustiquaire traitée à l'insecticide. En Tanzanie, un programme de quatre ans destiné à diffuser les moustiquaires a fait chuter de 80 % le taux de mortalité par le paludisme. En Finlande – pays pourtant peu concerné par ce fléau –, on avait autrefois une façon bien particulière de régler leur sort aux moustiques. Chaque année, on organisait un championnat du meilleur tueur de moustiques. Parfait piège à touristes, cette pratique a pourtant été abandonnée après son édition de 1995, ce qui laisse le gagnant de cette année-là en position de champion à vie : tout le monde se lève pour le Finlandais Harri Pellonpa, qui, lors de la rencontre de Laponie, totalisa 21 meurtres de moustiques en trois minutes, au seul moyen de ses mains nues et de prodigieux réflexes !

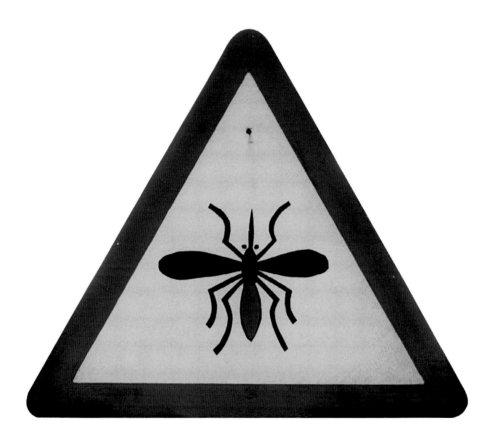

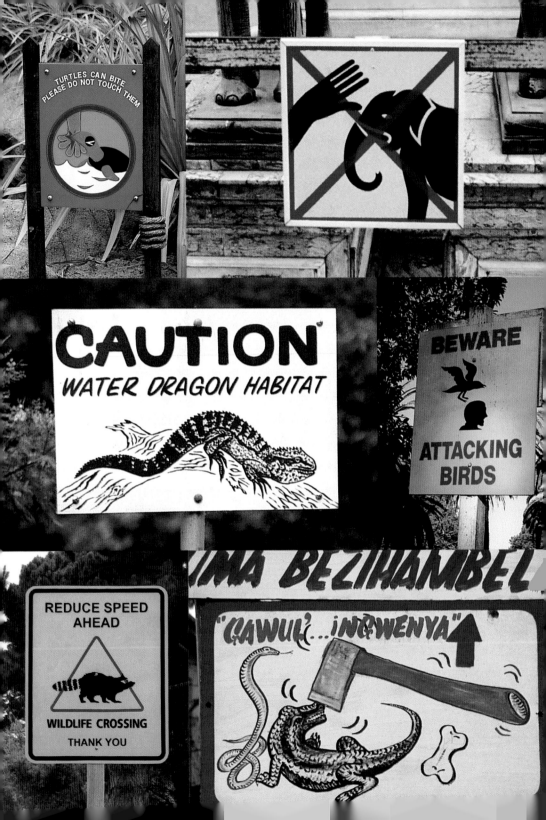

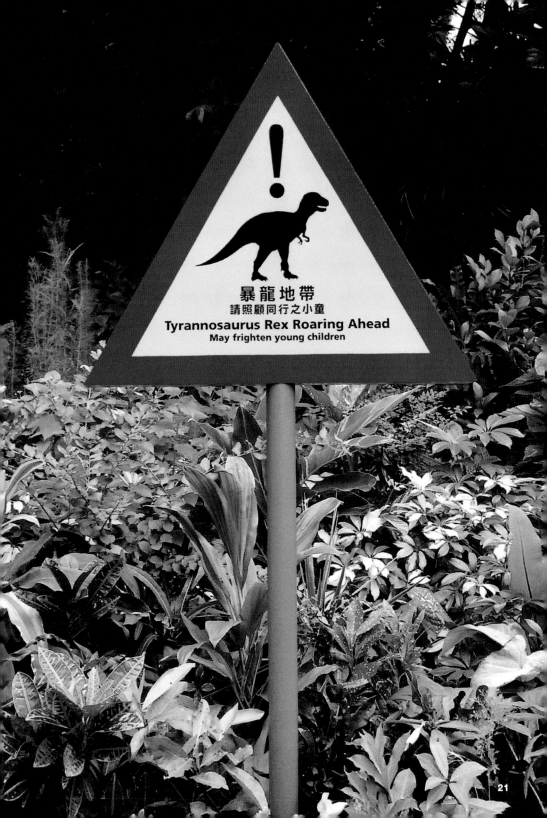

暴龍地帶
請照顧同行之小童
Tyrannosaurus Rex Roaring Ahead
May frighten young children

Don't Feed on the Animals!
Tiere füttern verboten
Ne pas nourrir les animaux

Don't touch the pigeons, warned the UK Ministry of Agriculture, Fisheries and Food in 1998. The birds within a 16-kilometer radius of Sellafield nuclear power station had become radioactive while roosting in the station's contaminated buildings. Analysis of the pigeons' droppings revealed levels of plutonium up to 800 times the norm, and their breast meat contained up to 50,000 Becquerels of cesium—40 times the European Union's food safety limit.

Beluga whales aren't having an easy time of it either. They carry thousands of man-made chemicals, including PCBs (polychlorinated biphenyls), thick, heat-resistant lubricants that leach from landfills. (The flesh of one whale caught by Norwegian whalers contained 50 different PCBs and 25 heavy metals.) PCBs lower the immunity of whales, dolphins and seals, making them vulnerable to otherwise mild diseases. High death rates among bottle-nosed dolphins in the Gulf of Mexico and striped dolphins in the Mediterranean have been attributed to PCBs.

Tauben bitte nicht berühren – so lautete 1998 eine Warnung des britischen Ministeriums für Landwirtschaft, Fischerei und Ernährung. Im Umkreis von 16 km um das Atomkraftwerk Sellafield waren die Vögel radioaktiv verseucht, weil sie in den kontaminierten Mauern des Gebäudes nisteten. Eine Analyse des Taubenkots ergab Plutoniumwerte, die die Norm um das 800fache überstiegen, während das Brustfleisch der Tauben 50 000 Becquerel Cäsium aufwies; der Sicherheitsgrenzwert für Nahrungsmittel in der EU liegt um das 40fache darunter.

Auch Belugawalen macht die Umweltverschmutzung zu schaffen. Sie sind mit Tausenden Industriechemikalien belastet, darunter PCB (polychlorierte Biphenyle). PCB sind dickflüssige, hitzeresistente Schmierstoffe, die aus Müllhalden auslaufen und ins Wasser gelangen (das Fleisch eines Wals, der norwegischen Walfängern vor die Harpune schwamm, enthielt 50 verschiedene PCB und 25 Schwermetalle). Diese Substanzen schwächen das Immunsystem von Walen, Delfinen und Robben und machen sie für sonst harmlose Krankheiten anfällig. PCB werden auch für die hohen Todesraten unter den Großen Tümmlern im Golf von Mexiko und den Streifendelfinen im Mittelmeer verantwortlich gemacht.

Ne touchez pas aux pigeons! Tel fut l'avertissement lancé en 1998 par le ministère britannique de l'Agriculture, de la Pêche et de l'Alimentation. Et pour cause : les volatiles qui nichaient dans un rayon de 16 km autour de la centrale nucléaire de Sellafield étaient devenus radioactifs à force de percher sur les bâtiments contaminés du site. Des analyses effectuées sur des fientes de pigeon révélèrent des taux de plutonium jusqu'à 800 fois supérieurs à la norme. Quant à leur chair, elle recelait jusqu'à 50000 Becquerels de césium, soit un taux 40 fois supérieur au seuil de tolérance fixé par la Communauté européenne pour les denrées alimentaires.

Pareillement rien ne va plus pour les baleines blanches. Elles stockent dans leur graisse des centaines de substances chimiques de synthèse, et notamment des PCB (polychlorobiphényles), lubrifiants à consistance épaisse, résistant à de très hautes températures, qui s'écoulent des sites d'enfouissement. (Les pêcheurs norvégiens ont déjà harponné une baleine dont la chair renfermait 50 PCB différents, ainsi que 25 métaux lourds.) Or, les PCB affaiblissent les défenses immunitaires des cétacés qui les absorbent (baleines, dauphins et phoques), les rendant plus vulnérables aux maladies même bénignes. On peut ainsi leur attribuer les taux de mortalité particulièrement élevés chez les dauphins souffleurs du golfe du Mexique et les dauphins bleus et blancs de Méditerranée.

TESSÉK
ZOO CSEMEGÉT
ADNI!

29
Man
Mann
Homme

Walk where
Wohin des Weges?
Marche à l'ombre

It all began with the threat of violence, or so it's thought. The side of the road on which we drive on depends on the side of the body our ancestors carried their swords. When people started moving around, in the days when roads were plagued by footpads and bandits, it paid to walk along the side of the road you could defend yourself best on. So a right-handed man (there probably weren't many women carrying swords and traveling alone) preferred to stay on the left, the better to reach over to his scabbard—carried on the left side of the body—with his right hand. Though if you were leading a cart, it was customary to sit towards the inside of the road, and thus drive on the right. (If you were leading a cart and carrying a sword, you were probably very confused.) Napoleon decreed that people drive on the right, though not all his conquered countries obeyed. Which might explain the current state of affairs—163 countries drive on the right, and 58 on the left. Those numbers aren't necessarily permanent though. Just look at Sweden, which decided in 1967 to change sides to conform with the rest of continental Europe, even though 12 years earlier 82.9

percent of the population had said it was happy on the left. The changeover took a week, and much careful coaching, but there were no fatalities. Elsewhere there are still which-side-of-the-road blackspots between bordering countries: Try driving between Pakistan and China, Thailand and Laos, Namibia and Angola, or arriving in Europe from the British Isles. But just as when there were only carts and swords, it's not really which side of the road you're driving on that poses the real danger, it's the people driving: Every year, more than 1.2 million people are killed on the world's roads.

Alles begann mit der Androhung von Gewalt, so wird jedenfalls behauptet. Auf welcher Straßenseite wir heute fahren, hängt davon ab, auf welcher Körperseite unsere Vorfahren ihre Schwerter trugen. Zu Zeiten, als noch Wegelagerer und Raubritter die Straßen unsicher machten, gingen die Menschen auf der Seite, auf der sie sich besser verteidigen konnten. Deshalb bevorzugte ein rechtshändiger Mann (Frauen waren selten allein unterwegs und trugen noch seltener Schwerter) die linke Straßenseite, da er so besser mit der rechten Hand sein Schwert

aus der links hängenden Scheide ziehen konnte. Wer den Weg allerdings auf einem Karren zurücklegte, saß auf der der Straßenmitte zugewandten Seite und fuhr folglich rechts (für karrenfahrende Schwertträger war das vermutlich äußerst verwirrend). Unter Napoleon war das Rechtsfahren per Verordnung vorgeschrieben, doch nicht alle Länder, die er erobert hatte, hielten sich daran. Darin mag eine Ursache für den heutigen Stand der Dinge liegen: In 163 Ländern herrscht Rechtsverkehr, 58 fahren links – was nicht bedeutet, dass es so bleiben muss. Schweden zum Beispiel beschloss 1967, sich an das übrige Kontinentaleuropa anzupassen und den Rechtsverkehr einzuführen, obwohl sich zwölf Jahre vorher 82,9 % der Schweden dafür ausgesprochen hatten, das Linksfahren beizubehalten. Der Wechsel wurde binnen einer Woche vollzogen und verlief dank vorsichtigen Fahrens ohne Todesopfer. Anderswo bilden die Grenzgebiete zwischen rechts und links fahrenden Ländern echte Gefahrenstellen. Das gilt für Fahrten von Pakistan nach China, von Thailand nach Laos, von Namibia nach Angola oder für die Rückkehr auf das europäische Festland nach einem Aufenthalt in Großbritannien.

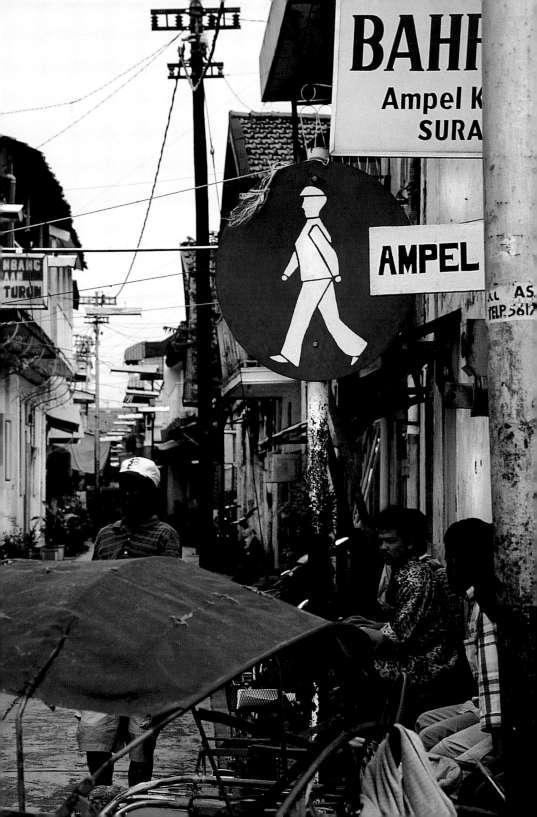

Aber wie bei Karren und Schwertern besteht die Gefahr nicht so sehr darin, auf welcher Seite der Straße man sich fortbewegt, sondern darin, wer einem entgegenkommt: Jährlich sterben weltweit über 1,2 Millionen Menschen im Straßenverkehr.

Tout a commencé, croit-on, dans la violence et la peur. Le côté de la route où nous conduisons dépend en effet du côté où nos ancêtres portaient leur épée. Lorsque l'on commença à voyager, à une époque où les routes étaient infestées de camelots détrousseurs et autres voleurs de grand chemin, il était recommandé de marcher du côté de la chaussée où l'on était le mieux à même de se défendre. Aussi un droitier (on comptait sans doute bien peu de droitières circulant seules sur les chemins, l'épée au côté) préférait-il rester du côté gauche, afin de mettre plus facilement la main droite au fourreau, qu'on portait alors sur le côté gauche. Si, en revanche, on conduisait un char ou une carriole, on avait coutume de s'asseoir non côté talus, mais côté route, et par conséquent, de rouler à droite. (Pour peu qu'on conduise un chariot tout en portant l'épée, il y avait de quoi y perdre son latin.) Napoléon décréta que l'on roulerait à droite, ce qui ne veut pas dire que tous les pays conquis par ses soins obtempérèrent. Voilà qui explique peut-être la cacophonie actuelle : on compte dans le monde 163 pays où l'on roule à droite, contre 58 où l'on roule à gauche – chiffres qui ne sont en rien immuables. Citons par exemple la Suède, qui résolut en 1967 de changer le côté de la circulation alors même que, douze ans plus tôt, 82,9 % de la population s'était déclarée satisfaite de rouler à gauche. La mise en place du nouveau système prit une semaine et nécessita un entraînement soigneusement orchestré, mais il n'y eut pas de victimes. Ailleurs, la confusion règne pour les pays frontaliers où l'on roule ici à gauche et là à droite. Tenez, essayez donc de passer en voiture du Pakistan en Chine, de la Thaïlande au Laos, de Namibie en Angola ou de pénétrer en Europe continentale depuis les Îles britanniques. Cependant, il est une chose qui n'a guère changé depuis le temps des carrioles et des rapières. Comme alors, le danger ne réside pas tant dans le côté de circulation que chez les conducteurs eux-mêmes. Rappellerons-nous que la route fait chaque année plus de 1,2 millions de morts ?

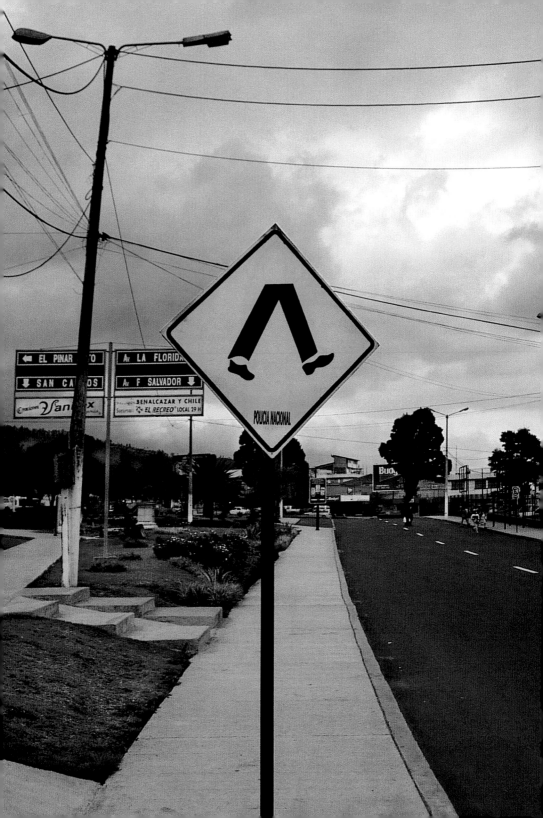

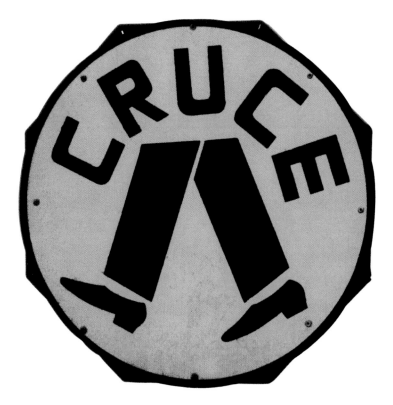

Look both ways
Schau nach links und rechts
Regardez à droite et à gauche

Roads with two-way traffic can be hazardous for elderly pedestrians—mainly because they don't look out for the traffic going in two directions, and they cross at undesignated places. Thirty-one percent of pedestrian fatalities in Australia between 1998 and 2002 involved people over the age of 65 (they make up just under 13 percent of the population). But elderly drivers are also a risk. Most of their accidents occur at intersections—turning left and failing to stop or yield—and when changing lanes, due to (a combination of) slower response times, poor vision and hearing, aching joints, drug prescriptions and dementia. Traffic signs with small lettering and lots of text are confusing; so are modern dashboard panels with too many lights and information. And in an impact air bags break fragile bones.

While some countries make efforts to keep unfit elderly drivers off the road—drivers over 70 in Norway require a health certificate to keep their license, while in neighboring Finland anyone over 45 must retake a test—losing a license can be dangerous for the elderly themselves. That's especially true in places like California, USA, where public transport is limited. "Giving up a driving license has far bigger consequences than it might seem," says 84-year-old Brenda Ross, a local councillor in "retirement city," Laguna Woods, USA. "To lose your license is to lose your means of socialization."

Straßen mit Verkehr von beiden Seiten können älteren Fußgängern gefährlich werden, vor allem, weil sie oft nicht mit Fahrzeugen aus zwei Richtungen rechnen und keine Zebrastreifen benutzen. Im Zeitraum zwischen 1998 und 2002 waren 31% aller Verkehrsopfer unter den Fußgängern über 65 Jahre alt (diese Altersgruppe umfasst knapp 13% der Bevölkerung). Aber auch ältere Autofahrer leben gefährlich. Die meisten Unfälle, in die sie verwickelt sind, ereignen sich an Kreuzungen (wenn beim Linksabbiegen nicht angehalten oder die Vorfahrt genommen wird) und beim Fahrbahnwechsel. Hauptursachen sind längere Reaktionszeiten, schlechtes Seh- oder Hörvermögen, Gelenkschmerzen, Nebenwirkungen von Medikamenten, Altersdemenz oder eine Kombination dieser Probleme. Wortreiche Verkehrsschilder mit zu kleinen Buchstaben sind verwirrend; dasselbe gilt für die Armaturenbretter moderner Autos mit zu vielen Leuchtanzeigen und Informationen. Darüber hinaus können Airbags bei einem Zusammenstoß spröde Knochen brechen.

Während einige Länder versuchen, altersschwache Fahrer von den Straßen fern zu halten – in Norwegen brauchen Fahrer über 70 eine Gesundheitsbescheinigung, um ihren Führerschein behalten zu können, während im benachbarten Finnland Autofahrer über 45 eine zusätzliche Fahrprüfung ablegen müssen –, ist es vielerorts für die Senioren selbst mit Gefahren verbunden, wenn sie die Fahrerlaubnis abgeben. Das gilt zum Beispiel für den US-Bundesstaat Kalifornien, in dem es kaum öffentliche Verkehrsmittel gibt. „Den Führerschein zu verlieren kann weitaus schwerere Folgen haben, als allgemein angenommen wird", erklärt die 84-jährige Brenda Ross, Ratsmitglied der Seniorenstadt Laguna Wood: „Ohne Auto ist man vom gesellschaftlichen Leben ausgeschlossen."

Les routes à double sens sont source de danger pour les piétons âgés, principalement parce que ces derniers oublient de regarder des deux côtés et traversent n'importe où. En Australie, 31 %

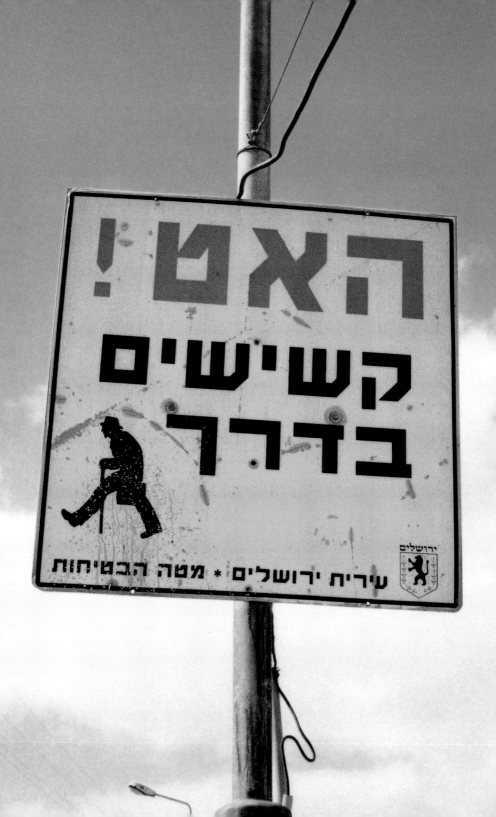

des accidents ayant coûté la vie à des piétons entre 1998 et 2002 concernaient des personnes de plus de 65 ans (cette classe d'âge constituant à peine 13 % de la population). Mais, si les seniors à pied sont particulièrement exposés, que les seniors au volant ne se croient pas à l'abri. La plupart des accidents adviennent à des intersections – lorsqu'ils tournent à gauche et omettent de s'arrêter ou de céder le passage – ou lors de changements de file, en raison d'une combinaison de facteurs (qu'il s'agisse de réflexes plus lents, d'une vue ou d'une ouïe plus basse, de raideurs articulaires, d'une prise de médicaments soporifiques ou de sénilité). Les panneaux de circulation comportant un texte trop long ou des inscriptions en trop petits caractères sont source de confusion, de même que les tableaux de bord modernes, fatras de voyants lumineux et d'informations simultanées. De plus, en cas de choc, les air bags risquent de briser les os fragiles des personnes âgées.

Si, dans certains pays, un effort est fait pour écarter de la route les conducteurs du troisième âge devenus inaptes (passé 70 ans, en Norvège, il faut fournir un certificat médical pour garder son permis, tandis qu'en Finlande, tous les conducteurs doivent repasser le leur après 45 ans), il peut être dangereux pour une personne âgée de se voir retirer son permis. Ceci se vérifie tout particulièrement dans des lieux tels que la Californie (États-Unis), où les transports publics sont peu développés. «Renoncer à sa voiture a des conséquences bien plus graves qu'il n'y paraît, explique Brenda Ross, 84 ans, conseillère municipale à la "retraite-city" de Laguna Woods (États- Unis). Perdre son permis, c'est se couper du monde.»

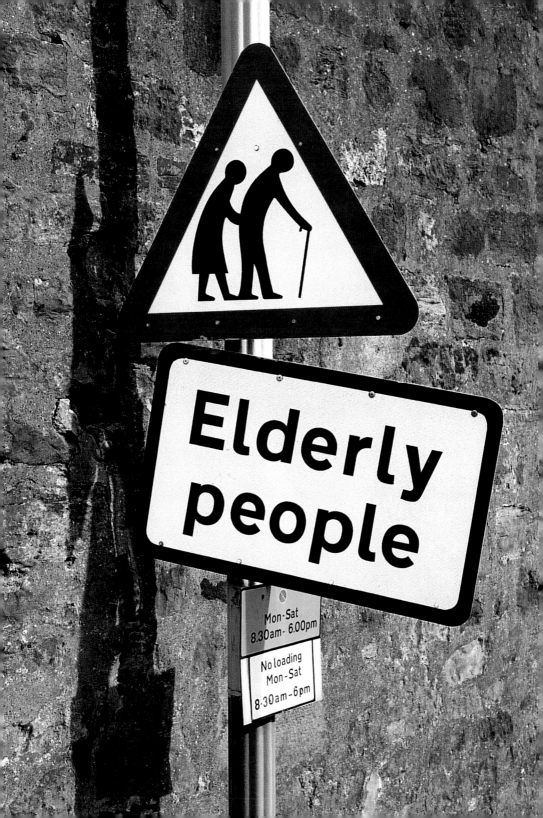

Litter
Müll
Ordures

"**We** get rid of about 1,300 tonnes of garbage a day. There's a general feeling of seriousness—even urgency—because although we're still closing off and pumping out new areas of Tokyo Bay, we only have enough space for 30 more years of garbage. So we're constantly trying to devise new ways to make the remaining space go further. The landfill areas are sealed off from the sea, and we sample the seawater around the walls periodically to make sure there's no leakage. I wish we didn't have to fill the sea with trash, but there's just nowhere else to put it." Masatsugu Samejima, 50, seafill operator, Tokyo.

„**Pro** Tag werden etwa 1300 t Müll angeliefert. Das nimmt allmählich bedrohliche Ausmaße an. Man könnte schon fast von einem Not-stand sprechen. Obwohl wir immer größere Teile der Bucht von Tokio abriegeln und auspumpen, reicht der Platz höchstens noch für den Abfall der nächsten 30 Jahre. Deshalb arbeiten wir ständig an neuen, rationelleren Lagerungsmethoden, um den Platz, den wir heute haben, besser auszunutzen. Die Mülldeponien sind zum Meer hin versiegelt, und das Wasser in der Umgebung wird regelmäßig untersucht, um sicherzugehen, dass es kein Leck gibt. Es wäre mir lieber, wenn wir das Meer nicht mit unserem Müll belasten würden, aber wir wissen einfach nicht wohin damit." Masatsugu Samejima, 50, Mitarbeiter einer Meeresdeponie, Tokio.

« **Nous** jetons environ 1 300 tonnes d'ordures ménagères par jour. Nous sommes dans une situation préoccupante, voire d'urgence – c'est le sentiment général ici. Car, malgré nos constants efforts pour enclaver et assécher de nouveaux sites dans la baie de Tokyo, d'ici 30 ans nous ne saurons plus où stocker nos déchets. C'est pourquoi nous cherchons sans relâche de nouveaux moyens pour optimiser l'espace déjà disponible. Les sites d'enfouissement sont protégés de la mer par des enceintes autour desquelles nous prélevons périodiquement des échantillons d'eau pour nous assurer qu'il n'y a pas de fuite. Je voudrais bien que la mer ne serve pas de dépotoir, mais il n'y a tout bonnement pas d'autre endroit où mettre nos ordures.» Masatsugu Samejima, 50 ans, employé sur un site d'enfouissement marin, Tokyo.

SEPARA TU

SEPARAR PA

RESIDUOS

A RECICLAR.

Radioactive
Verstrahlung
Radioactif

The world's worst nuclear power-er plant accident occurred on April 26, 1986, at Chernobyl in Ukraine. The disaster killed 31 workers at the reactor, and 135,000 people in Ukraine and neighboring Belarus had to be moved away from the zone of extreme contamination, an area covering 190km^2. Since then the region has seen a tenfold increase in thyroid cancer among children, and in certain parts of Belarus, it's expected that more than 35 percent of children who were under four at the time of the accident will develop the disease. However, radiation-related illnesses (such as leukemia) can develop after decades, and no one can estimate the long-term consequences to health of living on soil contaminated with high levels of radioactive cesium and strontium. The total number of victims may never be known.

Der bisher schwerste Unfall in einem Atomkraftwerk geschah am 26. April 1986 im ukrainischen Tschernobyl. Bei der Katastrophe kamen 31 Arbeiter im Reaktor selbst um, während in der Ukraine und dem benachbarten Weißrussland 135 000 Menschen aus dem 190 km^2 großen Gebiet, das am stärksten verstrahlt war, umgesiedelt werden mussten. Seitdem wurde in der gesamten Region ein Anstieg von Schilddrüsenkrebs bei Kindern um das Zehnfache verzeichnet. Es wird damit gerechnet, dass in bestimmten Gebieten Weißrusslands bei über 35% der Kinder, die zur Zeit des GAUs unter vier Jahre alt waren, diese Krankheit auftreten wird. Abgesehen davon können strahlenbedingte Erkrankungen (wie Leukämie) auch erst nach Jahrzehnten auftreten, und es ist praktisch unmöglich, die Langzeitschäden abzuschätzen, die entstehen, wenn Menschen in Gegenden leben, deren Böden hochgradig mit radioaktivem Cäsium und Strontium verseucht sind. Die Gesamtzahl der Opfer werden wir wohl nie kennen.

La plus grande catastrophe survenue sur un site nucléaire s'est produite le 26 avril 1986 à Tchernobyl (Ukraine). Elle a coûté la vie à 31 employés dans le réacteur même et nécessité l'évacuation de 135 000 Ukrainiens et Biélorusses vivant sur le secteur de contamination maximale qui s'étendait sur 190 km^2. Depuis, les cas de cancer de la thyroïde ont vu leur nombre décupler chez les enfants de la région. Dans certaines provinces du Belarus (pays limitrophe de l'Ukraine), des jours sombres se préparent : selon les prévisions, plus de 35 % des enfants qui avaient moins de quatre ans au moment du désastre seront frappés tôt ou tard par cette maladie. Toutefois, les affections liées aux radiations (notamment la leucémie) se déclarent parfois des dizaines d'années plus tard. D'autre part, la population locale vit aujourd'hui encore sur un sol contaminé, présentant des concentrations élevées en césium et en strontium radioactifs, et personne n'est à même d'évaluer les conséquences à long terme d'une exposition quotidienne de ce type. C'est dire que le nombre total des victimes de Tchernobyl ne sera peut-être jamais connu.

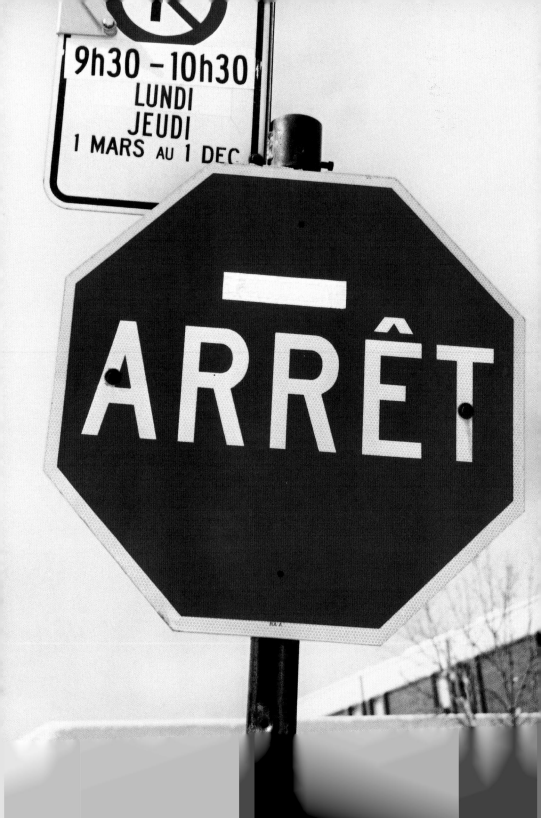

55
Stop
Halt
Arrêt

Octagon
Oktogon
Octogone

Making its debut in the US in 1915, the STOP sign is now the only official road sign internationally designated to have an octagonal shape. The sign is one of a kind for more than safety reasons—the shape means it requires more cutting (and thus wastage) than the more common squares, triangles and circles. The shape may have been decided on quickly, but getting the final design right took a little longer. At first it featured black letters on a white background, then quickly changed to black on yellow, then red on yellow, before eventually becoming the celebrated white on red. In the USA, it now has "cat's-eye" reflectors, a standard size of 76.2cm by 76.2cm and should be mounted at the height of 2.1m. It's now seen all over the world. While the signs in Spanish-speaking countries in Central and South America still have the Spanish "PARE" or "ALTO," Spain itself uses the English STOP. It wasn't the country's choice though—it was just complying with European Union regulations.

Seit es 1915 in den USA offiziell eingeführt wurde, ist das Stoppschild das einzige offizielle, internationale anerkannte Verkehrszeichen mit acht Ecken. Das Schild ist nicht nur aus Sicherheitsgründen einzigartig: Wegen seiner Form ist der Zuschnitt aufwändiger als bei herkömmlichen runden, drei- oder viereckigen Schildern, und es wird dabei mehr Material verbraucht. Auch wenn man sich auf die Form relativ rasch einigte, war es bis zum endgültigen Erscheinungsbild des Schildes ein langer Weg. Zuerst stand STOP in schwarzen Lettern auf weißem Grund, bald darauf in Schwarz auf Gelb, dann in Rot auf Gelb und endlich in der weltbekannten Endversion Weiß auf Rot. In den USA hat das Schild heute reflektierende Katzenaugen und ein Standardmaß von 76,2 x 76,2 cm, es sollte im Idealfall in 2,1 m Höhe installiert werden. Stoppschilder sieht man mittlerweile überall in der Welt. Während die spanischsprachigen Länder in Mittel- und Südamerika noch immer das spanische Wort PARE oder ALTO benutzen, steht in Spanien auf den Schildern das englische STOP. Daran haben allerdings die Spanier keine Schuld – sie halten sich nur an die Richtlinien der Europäischen Union.

Ayant fait ses débuts aux États-Unis dès 1915, le STOP est aujourd'hui le seul panneau de signalisation officiel à présenter partout, par convention internationale, une forme octogonale. S'il est unique en son genre, c'est autant par souci d'économie que pour des raisons de sécurité : ses huit angles nécessitent en effet un temps de coupe plus long (et occasionnent plus de perte) que les carrés, triangles et cercles habituels. Si la décision concernant l'adoption de l'octogone s'est faite assez rapidement, le choix du modèle a connu quelques flottements. On opta tout d'abord pour des caractères noirs sur fond blanc, puis on essaya le noir sur jaune, puis le rouge sur jaune, avant d'adopter définitivement notre bon vieux blanc sur rouge. Aux États-Unis, il est à présent doté de réflecteurs de type catadioptres, mesure 76,2 x 76,2 cm et doit être installé à 2,1 m du sol. Et on le rencontre aux quatre coins du globe. Si, dans les États hispanophones d'Amérique latine, on y lit encore « PARE » ou « ALTO », l'Espagne elle-même s'est mise au mot « STOP », à l'anglaise. Non par goût particulier pour la langue de Shakespeare : elle a simplement dû se conformer aux normes européennes.

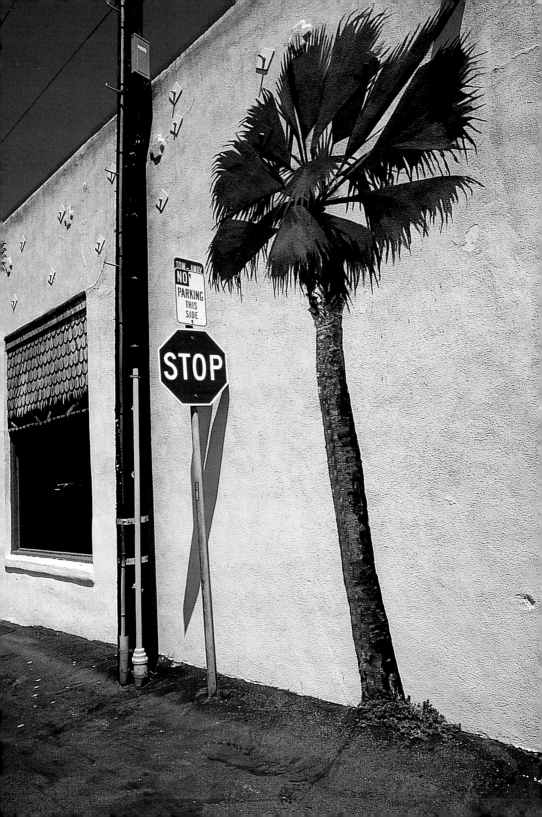

No bushmeat
Kein Dschungelfleisch
Pas de viande de brousse

About 80 percent of the meat eaten in Africa's Congo Basin comes from forest animals like chimps, gorillas, elephants and antelope. That's 1 million tonnes of wildlife—or bushmeat—every year. (People here eat as much meat as Europeans and Americans: about 100kg a year.) Before industrial logging began in 1986, large areas of forest in the region were untouched and virtually impenetrable, meaning that bushmeat hunting remained small-scale. But now that logging roads have been cut into the forest (0.8 percent of the Basin's 2 million km^2 of canopy is cut down each year), hunters—and loggers—have easier access to animals, and an easier time getting the meat out. Hunters hitch rides with the logging trucks, and the same vehicles allow them to return with more carcasses than they would have been able to carry on foot. The surplus is sold in nearby cities, where a lowland gorilla—of which only 100,000 remain—goes for about 16,250 Congo francs, or US$40.

Ungefähr 80% allen Fleisches, das in der afrikanischen Kongo-Region verzehrt wird, stammt von wilden Tieren wie Schimpansen, Gorillas, Elefanten und Antilopen. Die Gesamtmenge beläuft sich auf 1 Million t Wild – oder „Dschungelfleisch" – im Jahr. Die Bevölkerung der Region isst ebenso viel Fleisch wie die Europäer und Amerikaner, etwa 100 kg im Jahr. Bevor 1986 damit begonnen wurde, den Regenwald systematisch abzuholzen, war er weitgehend unberührt und praktisch undurchdringlich, so dass nur in geringem Umfang Jagd auf essbares Wild betrieben wurde. Mittlerweile ziehen sich Zugangspisten zu den Abholzungsgebieten durch den ganzen Wald (in der gesamten Region werden jährlich 0,8% der 2 Millionen km^2 Urwald im Kongo-Becken gefällt). Das macht es Jägern (und natürlich den Holzarbeitern) leichter, an die Tiere heranzukommen und das Fleisch abzutransportieren. Die Jäger trampen mit den Fahrzeugen der Abholzungsunternehmen in den Wald und nehmen ihre Beute auf demselben Weg mit zurück. Das heißt, dass sie wesentlich mehr Beute transportieren können, als wenn sie zu Fuß unterwegs wären. Das Fleisch kommt in den umliegenden Städten auf den Markt. Ein toter Flachlandgorilla, von denen inzwischen nur noch 100 000 Exemplare in freier Wildbahn leben, kostet dort 16 250 kongolesische Francs oder 40 US$.

Près de 80 % de la viande mangée dans le bassin du Congo, en Afrique, provient d'animaux sylvicoles: chimpanzés, gorilles, éléphants et autres antilopes. En termes de poids, c'est donc 1 million de tonnes de «viande de brousse» qui s'engloutit chaque année, avec une ponction à l'avenant sur la faune locale. (Dans la région, on mange autant de viande que les Européens ou les Américains, soit quelque 100 kilos par an.) Avant que l'exploitation forestière du bassin ne prenne une ampleur industrielle, c'est-à-dire avant 1986, celui-ci recelait de vastes secteurs boisés encore vierges et pratiquement impénétrables, si bien que la chasse au gibier de brousse ne se pratiquait qu'à petite échelle. Depuis, des routes ont été ménagées dans la forêt pour le transport du bois (le bassin est riche de 2 millions de km^2 de canopée, dont 0,8 % disparaît chaque année), assurant aux chasseurs (comme aux bûcherons) un accès plus facile aux animaux, et simplifiant le transport des carcasses. Les chasseurs n'ont plus qu'à se faire prendre en stop par les camions qui charrient le bois et, grâce à ces même véhicules, ressortent de la forêt bien plus chargés que s'ils faisaient le trajet à pied. Le surplus est vendu dans les villes environnantes, où un gorille des plaines – espèce dont il ne reste plus sur terre que 100 000 représentants – s'achète pour environ 16 250 FCFA (40 $ US).

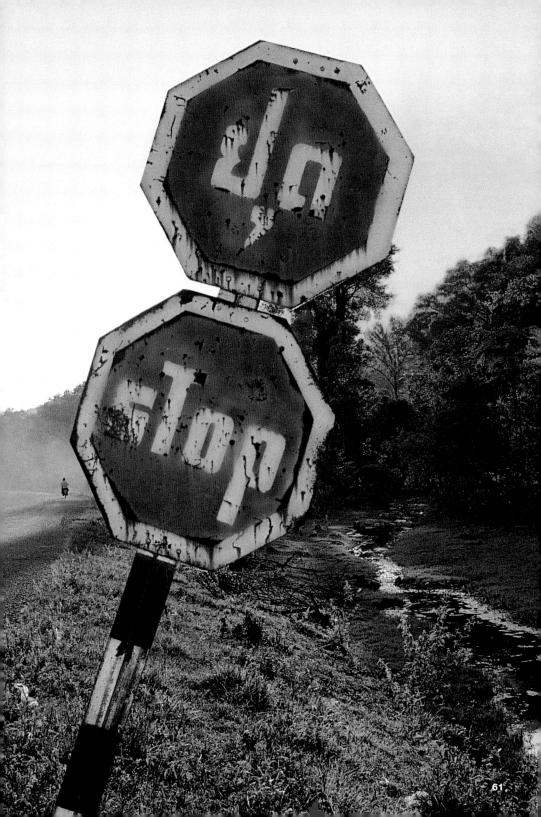

Halt
Halt
Halte

If you're in the USA and want a STOP sign on your street, write to your local traffic board—but be careful that the idea doesn't backfire. Too many STOP signs can lead to more accidents as people ignore the sign altogether or don't see it and rear-end the car in front. The signs can also increase congestion, treating your neighborhood to lines of frustrated and angry drivers. Drivers also accelerate more quickly between the signs to make up time, producing higher levels of air pollution (stopping 5,000 cars a day can generate 15 tons of additional pollutants a year), higher fuel consumption and extra noise pollution (all that gear changing and loud radios). And it's not just car drivers that might turn into a problem, you're going to have some exasperated cyclists too: STOP signs mean that all the momentum they've worked so hard to build up is lost when they're forced to stop at every junction.

Wenn du in den USA lebst und möchtest, dass an deiner Straße ein Stoppschild aufgestellt wird, musst du dich nur an die zuständige Behörde wenden. Aber diesen Schritt sollte man sich gut überlegen: Nicht immer bedeutet ein Stoppschild mehr Sicherheit. Ein Übermaß an Schildern kann sogar dazu führen, dass die Zahl der Unfälle (vor allem der Zusammenstöße) steigt, da die Verkehrszeichen wegen ihrer Vielzahl von den Autofahrern nicht zur Kenntnis genommen oder schlicht nicht gesehen werden, so dass es zu Auffahrunfällen kommt. Oft verlangsamen die Schilder den Verkehr so sehr, dass in der ganzen Gegend frustrierte und wütende Fahrer im Stau stecken. Außerdem tendieren Autofahrer dazu, zwischen zwei Stoppschildern stärker zu beschleunigen, um die verlorene Zeit aufzuholen. Das führt wiederum zu größerer Luftverschmutzung (5000 Autos am Tag, die halten und wieder anfahren, produzieren im Jahr bis zu 15 Tonnen zusätzlicher Schadstoffe), höherem Benzinverbrauch und mehr Lärmbelästigung (durch das Schalten und durch laute Radios). Und selbst Radfahrer werden von deiner Idee nicht allzu begeistert sein: Ein Stoppschild an jeder Ecke bedeutet für sie, dass sie, sobald sie mit viel Kraft in Fahrt gekommen sind, schon wieder abbremsen müssen.

Vous vivez aux États-Unis et vous souhaitez faire installer un stop dans votre rue. Que faire ? Écrivez à votre service local de la sécurité routière – mais prenez garde, car votre initiative risque de se retourner contre vous. Trop de stops peuvent être source d'une recrudescence d'accidents, les automobilistes ayant une fâcheuse tendance à passer outre, voire même à ne pas les repérer du tout et à emboutir la voiture qui s'est arrêtée devant eux. Les stops sont également source d'embouteillages, et vous feriez à votre quartier un cadeau empoisonné : des files d'autos klaxonnantes aux mains d'automobilistes exaspérés et agressifs. Au reste, même si la circulation est fluide, ces derniers vont accélérer entre deux stops afin de rattraper le temps perdu, ce qui ne fait qu'aggraver la pollution de l'air (on a calculé qu'un stop supplémentaire où s'arrêteraient 5 000 véhicules par jour génèrerait un surplus de polluants d'environ 15 tonnes). Autres conséquences : une consommation accrue de carburant et des nuisances sonores supplémentaires (vous savez, tous ces bruits de changements de vitesses et ces radios qui hurlent à tue-tête). Et vous ne subirez pas que les automobilistes : vous essuierez aussi la fureur des cyclistes. Pensez : s'ils doivent s'arrêter à chaque carrefour, tout l'élan gagné à la sueur du mollet est perdu à chaque fois !

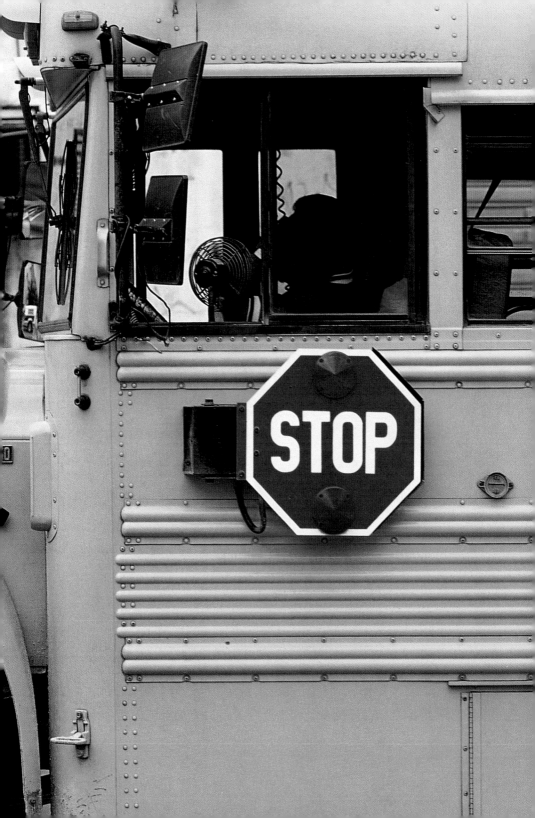

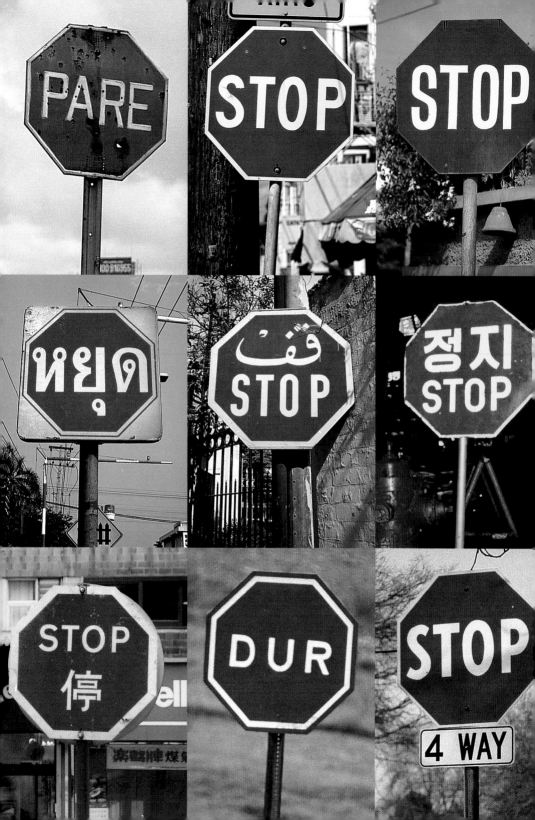

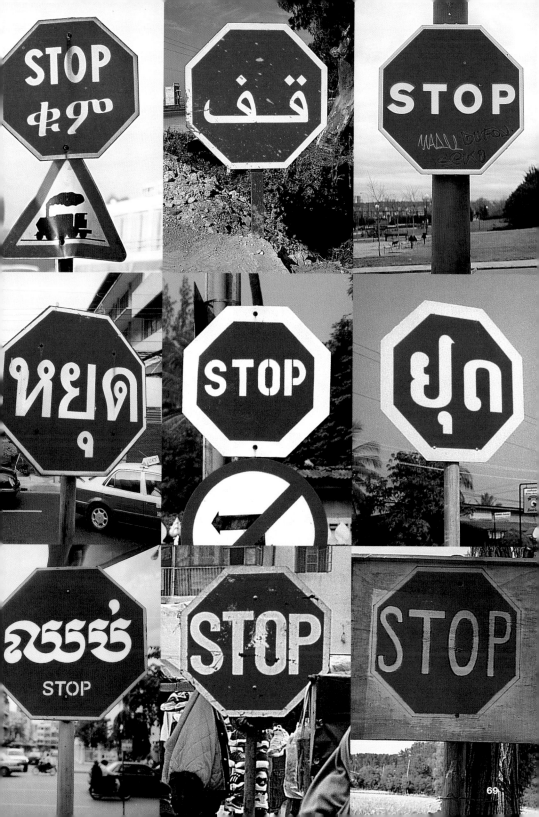

**71
Dog
Hund
Chien**

Dog food
Hund in Dosen
Chien en boîte

A Dalmatian is dragged out of a cage and into the alley behind Chilsung market in Taegu, South Korea. As a rope tightens around its neck, the dog defecates from shock. A metal rod connected to an electric generator is shoved into its mouth, and electricity surges through its frame. The process is repeated several times. Stunned but not dead, its entire body is seared with a blowtorch to burn off the fur. The whole procedure lasts an hour. Its purpose is to make the dog secrete as much adrenaline as possible at the moment of death. The adrenaline-rich meat is believed to be a powerful aphrodisiac, giving men long-lasting erections. Most of the two million dogs eaten annually in South Korea are roasted or prepared as *youngyangtang* (healthy soup), and sold for 20,000 won (US$16) per kilogram. While the meat spoils quickly if not refrigerated, the erection, legend has it, can last for hours.

Taegu (Südkorea): Ein Dalmatiner wird aus dem Käfig gezerrt und in die Gasse hinter den Chilsung-Markt geschleift. Als sich die Schlinge um seinen Hals zuzieht, macht der Hund vor Schreck einen Haufen. Ein Metallstab, der mit einem Generator verbunden ist, wird ihm in die Schnauze gesteckt, und er bekommt einen kräftigen Stromstoß. Dieser Prozess wird ein paarmal wiederholt. Wenn der Hund benommen, aber noch nicht tot ist, wird ihm mit einem Gasbrenner am ganzen Körper das Fell abgesengt. Die gesamte Prozedur dauert etwa eine Stunde. Man will den Hund dazu bringen, im Moment seines Todes so viel Adrenalin wie möglich abzusondern, da adrenalinhaltiges Hundefleisch als Potenzmittel gilt, das Männern angeblich zu besonders lang anhaltenden Erektionen verhilft. Der Großteil der 2 Millionen Hunde, die jährlich in Südkorea auf den Tisch kommen, wird gebraten oder zu *youngyangtang* (Gesundheitssuppe) verarbeitet. Man bekommt Hundefleisch für 20 000 Won (24 US$) das Kilogramm. Während das Fleisch ungekühlt rasch verdirbt, können die Erektionen, so heißt es jedenfalls, stundenlang andauern.

Un dalmatien est extirpé de sa cage et traîné dans une allée, derrière le marché Chilsung, à Taegu (Corée du Sud). Étranglé à l'aide d'une corde, le chien défèque sous le choc. Une tige métallique reliée à un générateur est enfilée dans sa bouche, puis on lui envoie une série de décharges électriques. Assommé mais pas mort, l'animal est ensuite passé au chalumeau afin de lui calciner le poil et de le peler. Toute cette procédure dure une heure et vise à faire secréter au chien autant d'adrénaline que possible au moment de la mort. On vous expliquera qu'une viande riche en adrénaline est un puissant aphrodisiaque, garantie de très longues érections. Les 2 millions de chiens consommés annuellement en Corée du Sud sont pour la plupart rôtis ou préparés en *youngyangtang* (soupe de santé), puis vendus 20 000 WS (16 $ US) le kilo. La viande se gâte vite si elle n'est pas correctement réfrigérée, mais l'érection, à en croire la légende, durerait des heures entières.

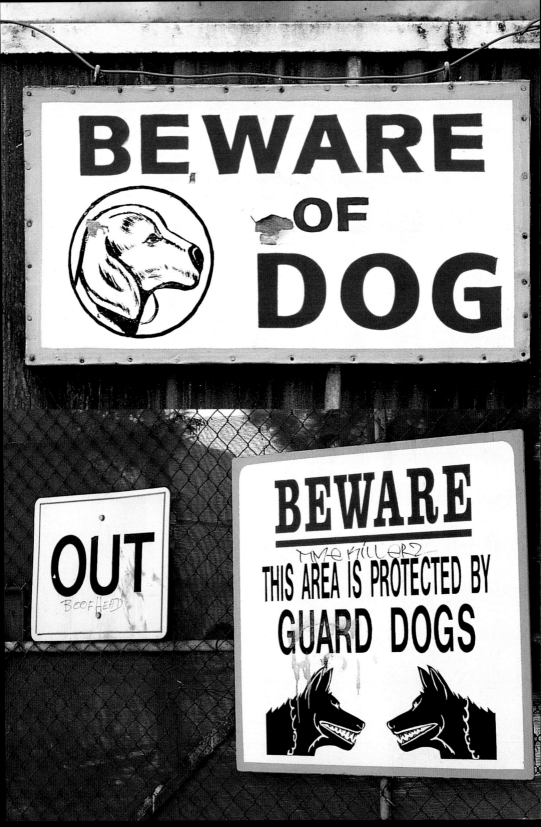

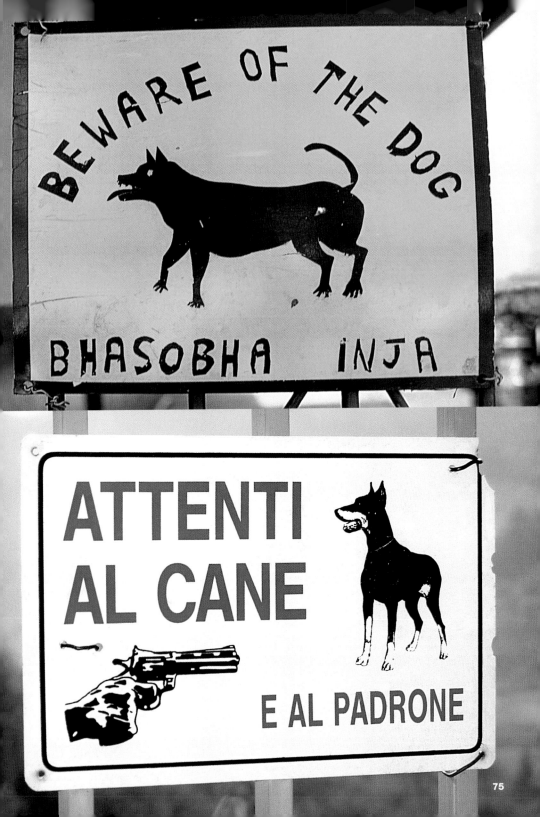

Unemployment
Arbeitslos
Chômage

In January 2001, 548 cats and dogs lost their jobs after cutbacks at a food-tasting laboratory in the UK. Just another day in the ultra-competitive US$11-billion pet food industry. For all the competition, most pet food—whether it's dry or from a tin—is made from the same things: meat, grain and animal fat. Where the ingredients come from is another matter, according to Ann Martin, author of *Food Pets Die For*, an investigation into the pet food industry. The meat in a tin of chicken-flavored food, she says, may be made up of rendered chicken spleens, intestines, genitals, pancreas, gizzards or hearts. Alternatively, she alleges, it could be roadkill, diseased meat, zoo animals or dogs and cats. Grain, according to Ann, is usually the leftovers swept off mill floors, while animal fat could come from grease formed during rendering.

Als im Januar 2001 in einem britischen Labor für Tierfutter-Geschmackstests Arbeitsplätze abgebaut wurden, waren unter den Betroffenen 548 Katzen und Hunde. In der US-amerikanischen Industrie für (Haus-)Tierfutter, die ein Volumen von 11 Milliarden US$ hat und in der ein beinharter Konkurrenzkampf herrscht, ist so etwas an der Tagesordnung. Trotz allen Wettbewerbs besteht Tiernahrung, ob trocken oder aus der Dose, meist aus denselben Zutaten: Fleisch, Getreide und tierisches Fett. Woher diese Zutaten kommen, ist eine andere Frage, der Ann Martin in ihrem Buch *Food Pets Die For* nachgeht, in dem sie die Tierfutterindustrie unter die Lupe nimmt. Sie behauptet, das Fleisch in einer Dose Tierfutter mit Hühnergeschmack könne aus ausgelassenen Hühnermilzen, Gedärmen, Genitalien, Bauchspeicheldrüsen, Mägen und Herzen bestehen. Auch überfahrenes Wild, Kadaver, Zootiere sowie Hunde und Katzen könnten in der Dose enden. Das Getreide besteht nach Anns Angaben hauptsächlich aus Kornabfällen, die auf dem Boden der Mühlen zusammengefegt werden, während das Tierfett beim Auslassen der Fleischmasse entsteht.

En janvier 2001, 548 chiens et chats britanniques perdirent leur emploi, leur laboratoire de dégustation d'aliments ayant procédé à une compression du personnel. Une journée comme les autres dans l'industrie alimentaire pour animaux de compagnie… secteur d'autant plus compétitif qu'il pèse 11 milliards de dollars US. Cependant, cette concurrence féroce entre fabricants ne contribue guère à varier l'alimentation du consommateur, puisque la majeure partie des produits distribués – qu'il s'agisse de croquettes ou de boîtes – sont de composition identique: viande, céréales et graisse animale. D'où proviennent ces ingrédients, voilà qui est beaucoup moins clair. Demandez plutôt à Ann Martin, auteur de l'ouvrage *Food Pets Die For* (ces aliments dont nos animaux meurent [d'envie]), où elle mène l'enquête sur l'industrie des aliments pour chiens et chats. La viande contenue dans une boîte de pâtée goût poulet, indique-t-elle, peut être obtenue à partir d'un bouilli plâtreux de divers abats: intestins, parties génitales, pancréas, cœurs et gésiers. Lorsqu'elle ne provient pas d'un animal écrasé sur la route ou mort d'une maladie infectieuse, d'un pensionnaire de zoo, voire de congénères. Les céréales? D'après Ann, de vulgaires résidus ramassés en balayant le plancher des minoteries. La graisse animale? Éventuellement, celle récupérée en faisant bouillir les abats.

POZOR!
HUD PES

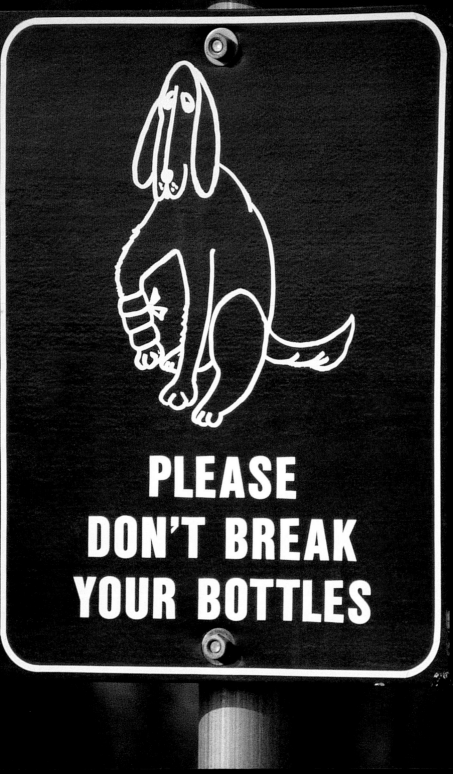

honden
aanlijnen

beslist geen
hondenpoep

VERBODEN TOEGANG
ART. 461 WETB. V. STRAFR.

J'AIME
MON QUARTIER

JE RAMASSE

RÈGLEMENT SANITAIRE DÉPARTEMENTAL ART. 99-2
INFRACTION PUNIE PAR UNE AMENDE
POUVANT ATTEINDRE 3000F (457€)

Pavement
Straßenpflaster
Trottoirs

Every day, Paris's 160,000 dogs (one for every 13 people) dump about 16 tonnes of excrement on city streets. The cleanup operation costs 11 million euros (US$13 million) annually. To combat rising mountains of shit, authorities in other cities encourage owners to clean up after their pets: Public parks in Hong Kong provide pet toilets (sandboxes), while Dutch parks have installed "doggy bag" dispensers. In Singapore, you can be fined up to S$1,700 ($600) for not scooping, while Argentinians want to insert microchips in dogs' ears that contain the owner's identification. Why the fuss? Feces can contain parasites fatal for humans. Roundworm eggs, for example, can remain in the ground for years, posing a risk to anyone who touches the ground and then their mouth (children and people in wheelchairs are the most common victims). Back in Paris, there's another, less scientific, reason: hospitals there treat over 650 people a year injured after slipping on dog mess.

Tag für Tag verschmutzen 160 000 Pariser Hunde (auf 13 Einwohner kommt ein Hund) die Straßen und Bürgersteige der Stadt mit etwa 16 Tonnen Exkrementen. Die Säuberung des Pflasters kostet die Stadt jährlich 11 Millionen € (13 Millionen US$). Im Kampf gegen die Berge von Hundekot sind anderswo die Tierhalter angehalten, hinter ihren Lieblingen herzuwischen. In Hongkong gibt es in öffentlichen Parks zu Hundetoiletten erklärte Sandkästen, während man in holländischen Parks Plastiktütchen für Hundekot aus dem Automaten ziehen kann. In Singapur drohen dem unbedachten Herrchen saftige Geldstrafen bis zu 1700 Singapur Dollar (600 US$), während argentinische Behörden planen, Hunden Mikrochips mit den Daten ihrer Halter ins Ohr zu setzen. Warum die ganze Aufregung? Kot kann Parasiten übertragen, die für Menschen lebensgefährlich sind. Die Eier des Spulwurms halten sich beispielsweise jahrelang im Boden und werden so zum Risiko für jeden, der das Pflaster berührt und anschließend die Finger an den Mund führt (am stärksten betroffen sind Kinder und Rollstuhlfahrer). In Paris ist man aus einem weiteren, weniger wissenschaftlichen Grund auf Sauberkeit bedacht: Jährlich werden in Pariser Krankenhäusern über 650 Personen behandelt, die sich beim Ausrutschen auf Hundekot verletzt haben.

Chaque jour, les 160 000 chiens de Paris (on en compte un pour 13 habitants) larguent sur les rues et trottoirs environ 16 tonnes d'excréments, qui coûtent chaque année à la municipalité 11 millions d'euros (13 millions $US) en frais de nettoiement. Face aux montagnes grandissantes de crottes, les pouvoirs publics sont passés à l'offensive et mènent campagne pour encourager les maîtres à ramasser les déjections de leurs animaux. À chaque pays sa méthode : à Hong-kong, les jardins publics sont équipés de «canisettes», sortes de bacs à sable où les chiens peuvent faire leurs besoins; aux Pays-Bas, on trouve dans les parcs des distributeurs de «doggy bags», sachets papier permettant le ramassage; à Singapour, ceux qui omettent de nettoyer encourent une amende de 1 700 $ SI (600 $ US), tandis qu'en Argentine, on envisage de greffer dans les oreilles des chiens des puces électroniques sur lesquelles seraient enregistrées l'identité et les coordonnées du maître. Mais pourquoi tant de précautions ? Parce que les excréments sont susceptibles de contenir des parasites mortels pour l'homme. Les œufs d'ascarides, pour ne citer qu'eux, peuvent rester enfouis dans la terre des années durant, ce qui génère un risque pour quiconque touche le sol, puis porte les mains à sa bouche (les enfants et les personnes circulant en chaise roulante sont les victimes les plus fréquentes de ce perfide petit ver). À Paris, on a cependant une raison supplémentaire, moins scientifique celle-là, de nettoyer les trottoirs : les hôpitaux parisiens traitent plus de 650 cas par an de personnes blessées après une glissade sur crotte.

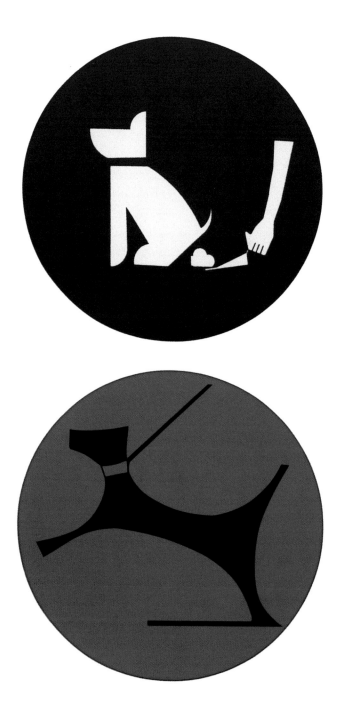

IO NON POSSO ENTRARE

87
Transport

Airless
Vakuum
De l'air!

Fresh air is made up of nitrogen (78 percent), oxygen (21 percent) and 11 other gases and compounds. Normally, the least common is nitrogen dioxide (0.000002 percent), but vehicle emissions can cause this level to rise. The nitrogen dioxide then reacts with sunlight to cause photochemical smog (as is often seen in Mexico City, for example) and ozone, a gas that can cause lung damage and asthma. Vehicles also emit suspended particle matter (mainly soot from dirty engines), lead and carbon monoxide. The World Health Organization estimates that 700,000 deaths in developing countries could be prevented every year if these three pollutants were reduced. But that's not likely to happen soon. The World Bank says that the number of motor vehicles worldwide will be 816 million in 2010 (up from 580 million in 1990). In Bangkok, 300 to 400 additional cars appear on the street every day—despite estimates that drivers there already spend a total of 44 days a year stuck in traffic.

Frische Luft besteht aus Stickstoff (78%), Sauerstoff (21%) sowie aus elf weiteren Gasen und Substanzen. Normalerweise kommt Stickstoffdioxid nur in ganz geringen Mengen vor (0,000002%), aber durch Fahrzeugemissionen kann der Anteil zunehmen. Das Stickstoffdioxid reagiert dann mit Sonnenlicht und erzeugt so fotochemischen Smog (wie er zum Beispiel in Mexiko-Stadt häufig auftritt) sowie Ozon, ein Gas, das Lungenschäden und Asthma verursachen kann. Fahrzeuge sondern weiterhin Partikel (hauptsächlich Ruß aus verschmutzten Motoren), Blei und Kohlenmonoxid ab. Die Weltgesundheitsorganisation schätzt, dass in Entwicklungsländern 700 000 Todesfälle pro Jahr vermieden werden könnten, wenn diese drei Schadstoffe reduziert würden. Aber das wird so bald nicht geschehen. Die Weltbank schätzt, dass die Zahl der Fahrzeuge mit Motorantrieb bis zum Jahr 2010 weltweit auf 816 Millionen ansteigen wird (1990 waren es 580 Millionen). In Bangkok kommen täglich 300 bis 400 zusätzliche Autos auf die Straßen – obwohl es Schätzungen gibt, wonach Autofahrer dort jetzt schon durchschnittlich 44 Tage pro Jahr im Stau stehen.

À l'état pur, l'air est constitué d'azote (à 78 %) et d'oxygène (à 21 %), mais aussi de onze autres gaz et composés chimiques. Parmi ceux-ci, le dioxyde d'azote est celui présentant la concentration la plus faible (0,000 002 %), mais il est l'un de ceux dont le volume augmente sous l'effet des émissions de gaz d'échappement. Il entre alors en réaction avec le rayonnement solaire et forme un épais brouillard photochimique (comme on en voit souvent au-dessus de Mexico, par exemple), tout en produisant de l'ozone, un gaz pouvant provoquer de l'asthme et diverses lésions pulmonaires. Les moteurs émettent de surcroît des particules de matière qui restent en suspension dans l'air (principalement de la suie, lorsqu'ils sont encrassés), ainsi que du plomb et du monoxyde de carbone. L'Organisation mondiale de la santé a calculé qu'en réduisant ces trois polluants, 700 000 vies humaines pourraient être épargnées chaque année dans les pays en voie de développement. Or, selon les estimations de la Banque mondiale, le parc automobile de la planète comptera 816 millions de véhicules d'ici 2010 (contre 580 millions en 1990). Dans les rues de Bangkok, 300 à 400 nouvelles voitures viennent grossir chaque jour le flot de la circulation, en dépit d'embouteillages plutôt dissuasifs : on estime que, sur une année, un automobiliste bangkokien passe l'équivalent de 44 jours dans les encombrements.

Car blessing
Autosegen
Bénédiction de véhicule

At the Zenkoji Temple in Nagano, Japan, Buddhist priests specialize in blessing cars; the ¥5,000 (US$46) fee includes a wooden talisman to hang from the rearview mirror. Catholic priests sometimes formally bless cars, although a French bishop recently called for an end to this "hocus-pocus." Kenya's taxi drivers just paint a prayer across their vehicle. "We are asking God to protect us from the hazards of our roads," says Robert Maina Kamanda, of Bombolulu (his taxi is decorated with "The Lord is my shepherd," in Swahili). "I feel safer because the Bible says, 'Ask and you shall receive.'"

Im Zenkoji-Tempel in Nagano (Japan) haben sich buddhistische Mönche darauf spezialisiert, Autos zu segnen (ein Segen kostet 5000 Yen oder 46 US$ einschließlich eines hölzernen Talismans, der an den Rückspiegel gehängt wird). Katholische Priester segnen ebenfalls hin und wieder Autos (auch wenn in Frankreich kürzlich ein Bischof empört forderte, diesem „Hokuspokus" ein Ende zu setzen). In Kenia malen Taxifahrer einfach Gebete auf ihre Fahrzeuge. „Wir bitten Gott um Schutz vor den Gefahren der Straße", erklärt Robert Maina Kamanda aus Bombulu (sein Taxi trägt die Aufschrift ‚Der Herr ist mein Hirte' in Suaheli). „So fühle ich mich sicherer, denn in der Bibel steht: ‚Bittet, dann wird euch gegeben.'"

Au temple Zenkoji de Nagano (Japon) officient quelques prêtres bouddhistes spécialistes de la bénédiction automobile (au tarif de 5000 ¥ [46 $ US], avec talisman de bois à suspendre au rétroviseur fourni sans supplément). Il arrive aussi que des prêtres catholiques consacrent dans les règles un véhicule (bien qu'en France, un évêque ait récemment appelé à ce que cessent ces rituels « charlatanesques »). Les chauffeurs de taxi kenyans se contentent quant à eux de peindre une prière en travers de leur carrosserie. « Nous demandons à Dieu de nous protéger contre les dangers de nos routes », indique Robert Maina Kamanda, de Bombolulu (son taxi porte la mention « Le seigneur est mon berger » en swahili). « Comme ça, poursuit-il, je me sens plus en sécurité, car la Bible dit, "Demandez et il vous sera accordé". »

Car Parts
Ersatzteile
Pièces détachées

A car is made up of 15,000 different parts. Sixty-six percent of them are made of iron or steel, some are aluminum and other metals (including toxic cadmium and beryllium), and about 100 kilograms are made of 60 different types of plastics. Every year the automobile industry consumes nine percent of the world's steel production, eight percent of the world's aluminum, and 40 million tonnes of plastic. Because cars are full of so many different materials, they are difficult to recycle. (How do you get the talcum powder out of the electrical insulation?) Then there are tires. In the USA, the world's biggest car producer, where there is nearly one car per person, 300 million tires are thrown away every year. They can't be burned (they release toxic fumes), and they don't decompose, so alternative uses have to be found. Shredded, they make floor tiles and padding for children's playgrounds; one French company utilizes them in sound barriers built along highways and railroad lines; and they are also dumped in the ocean—scientists have found that they make perfect artificial reefs.

Autos sind aus 15 000 Einzelteilen zusammengesetzt. Davon bestehen 66% aus Eisen oder Stahl, andere sind aus Aluminium oder anderen Metallen (darunter toxisches Kadmium und Beryllium), und 60 verschiedene Arten von Kunststoff summieren sich auf etwa 100 kg. Jedes Jahr verbraucht die Automobilindustrie 9% der weltweiten Stahlproduktion, 8% allen Aluminiums und 40 Millionen Tonnen Plastik. Weil Autos aus so vielen verschiedenen Materialien bestehen, sind sie schwer zu recyceln. (Wie bekommt man das Talkum aus der Kabelisolierung?) Und dann sind da noch die Reifen. In den USA, dem größten Autoproduzenten der Welt (auf fast jeden Amerikaner kommt ein Auto), landen jährlich 300 Millionen Reifen auf dem Müll. Sie können nicht verbrannt werden, weil dabei giftige Gase freigesetzt werden, und zersetzen tun sie sich auch nicht. Also muss man Alternativen finden: Geschredderte Autoreifen werden zu Auslegeware oder zu Belägen für Kinderspielplätze verarbeitet, ein französisches Unternehmen verwendet sie in Lärmschutzmauern an Autobahnen und Bahnstrecken, und sie werden ins Meer geworfen – wissenschaftliche Forschungen haben ergeben, dass Autoreifen ideale künstliche Riffe und Wellenbrecher abgeben.

Un véhicule automobile recèle quelque 15 000 pièces détachées. La plupart (66 %) sont en fer ou en acier, quelques-unes en aluminium, mais d'autres métaux sont également utilisés (notamment le cadmium et le béryllium, tous deux hautement toxiques), ainsi que 60 types de plastiques qui représentent environ 100 kg. L'industrie automobile absorbe chaque année 9 % de la production mondiale d'acier, 8 % de celle d'aluminium et 40 millions de tonnes de plastiques. Sachant qu'une voiture réunit autant de matériaux différents, on comprendra qu'elle soit difficile à recycler (comment éliminez-vous le talc contenu dans le système d'isolation électrique?) Et que dire des pneus ? Aux États-Unis, premier producteur automobile mondial et énorme consommateur, avec près d'un véhicule par habitant, ce sont 300 millions de pneumatiques qui sont jetés chaque année. Or, on ne peut pas les brûler (ils relâcheraient des gaz toxiques) et ils ne se décomposent pas. La gageure était donc de trouver des modes de recyclage. Une fois découpés, ils forment d'exquis carrelages plastique ou des revêtements antichoc pour les aires de jeu. Une entreprise française les utilise même pour fabriquer des murs antibruit qui borderont les autoroutes et les voies ferrées. Enfin, on les jette parfois en mer : en effet, les scientifiques ont découvert qu'ils formaient de parfaits récifs artificiels.

Speed bumps
Bodenschwellen
Ralentisseurs

Ouch! Have I just run over someone or is that my coccyx cracking? The bumps that have spread over the planet's roads since the 1970s are not as harmless as they look. Traffic humps, sleeping policemen or traffic calming measures—whatever they're called—are always annoying somebody. Opponents have a list of objections: They jolt and injure disabled drivers; they make non-disabled drivers disabled by giving them neck injuries; they increase pollution, because cars have to keep braking and accelerating, and they can be lethal. The London Ambulance Service estimates that every minute added to an ambulance journey kills 500 patients—mostly in cardiac arrest—every year, even with German speed cushions (laid out in sets of threes, to slow down cars but not ambulances). But bumps have their supporters too; demand for traffic calming measures in the UK outstrips supply. Though for now, the Dutch round-topped hump has the edge over the squarer, flat-topped kind (popular since 1990), and the sinusoidal hump—gentler angles, softer on the back—is way too rare for the angry anti-humpers, there will soon be an alternative. Transport scientists at Dunlop Transcalm have developed a clever road hump that deflates; the rubber bump is filled with air, which is released if the car is going below the speed limit. This new bump on the block could save lives and coccyxes alike.

Autsch! Habe ich da gerade jemanden überfahren, oder war das mein Steißbein? Die Buckel, die sich seit Anfang der 1970er Jahre auf den Straßen in aller Welt breit gemacht haben, sind nicht so harmlos, wie sie aussehen. Tempobremsen, Bodenschwellen, Maßnahmen zur Verkehrsberuhigung – wie man sie auch bezeichnet, irgendjemand ärgert sich immer über sie. Die Gegner bringen eine ganze Reihe von Einwänden vor: Behinderte Fahrer würden durchgeschüttelt und könnten sich dabei verletzen, die Buckel könnten durch Halsverletzungen aus Gesunden Behinderte machen; die Buckel führten zu erhöhter Luftverschmutzung, da Autofahrer gezwungen seien, ständig zu bremsen und wieder zu beschleunigen – und sie könnten tödliche Folgen haben: Beim Londoner Krankenwagen-Notdienst wird geschätzt, dass jede zusätzliche Minute im Krankenwagen jährlich bei 500 Patienten zum Tode führt, vor allem bei solchen mit Herzstillstand. Das passiert sogar bei den modernen „Kissen" deutscher Bauart, die in Dreiergruppen platziert werden und die Geschwindigkeit von Autos, nicht aber Krankenwagen herabsetzen sollen. Doch Bodenschwellen haben auch Befürworter: In Großbritannien überschreitet die Nachfrage nach Maßnahmen zur Verkehrsberuhigung bei weitem das Angebot. Obwohl der rundgewölbte Buckel niederländischen Typs der seit den 1990er Jahren beliebten eckigeren Bodenschwelle derzeit noch überlegen und der „Nasenbuckel" (flachere Winkel, sanfter in der Wirkung auf den Rücken) nach Ansicht von Schwellengegnern viel zu selten zu finden ist, wird es bald eine Alternative geben: Verkehrsexperten bei Dunlop Transcalm haben eine intelligente Bodenschwelle entwickelt, die nur bei Bedarf in Aktion tritt. Der Gummibuckel ist mit Luft gefüllt, die automatisch abgelassen wird, wenn das herannahende Auto die vorgeschriebene Geschwindigkeit einhält. Die neue Tempobremse soll so gleichermaßen zur Rettung von Menschenleben und Steißbeinen beitragen.

Aïe ! Je viens d'écraser quelqu'un ou c'est mon coccyx qui se frac-

ture ? Ces ralentisseurs qui se répandent sur toutes les routes de la planète depuis les années 70 sont moins inoffensifs qu'il n'y paraît. Dos d'ânes, policiers endormis, régulateurs de la vitesse de circulation : quel que soit le nom dont on les affuble, ils ennuient toujours quelqu'un. Leurs détracteurs disposent d'une liste d'arguments : les ralentisseurs secouent et blessent les conducteurs handicapés ; par leur faute, les automobilistes valides deviennent des handicapés, car ils causent des traumatismes cervicaux ; ils contribuent à accroître la pollution, en contraignant les véhicules à freiner puis accélérer constamment ; enfin, ils peuvent causer la mort. Selon les estimations du Service des ambulances londonien, chaque minute perdue sur le trajet d'une ambulance tue 500 patients par an (principalement des personnes victimes d'un arrêt cardiaque), et ce malgré les « coussins de vitesse » allemands (disposés par trois de façon à ralentir les voitures, mais pas les ambulances). Cependant, les ralentisseurs ont aussi leurs défenseurs : au Royaume-Uni, la demande de régulateurs de vitesse est si forte que les fournisseurs sont débordés. Bien que, pour l'heure, le ralentisseur hollandais à dos arrondi reste plus répandu que le type carré à dos plat (populaire depuis 1990 seulement), et que celui dit « en sinusoïde » (aux angles plus doux, pour ménager le dos du conducteur) soit encore bien trop rare au goût des anti-ralentisseurs furibonds, une autre option devrait bientôt être disponible qui reléguera les dos d'âne aux temps préhistoriques. Les spécialistes du transport chez Dunlop Transcalm ont en effet mis au point un ralentisseur intelligent qui se dégonfle ! Il s'agit d'un boudin de caoutchouc capable d'évacuer l'air qu'il contient si le véhicule qui passe roule en dessous de la vitesse maximale autorisée. Voilà qui va faire sensation dans votre quartier : le nouveau dos d'âne qui sauve autant de coccyx que de vies !

Only 12 out of every 1,000 Nigerians owns a car. This makes public transport a lucrative business. "The transport system here is controlled by gangs," says Seye Solola, a bus conductor in Lagos. The most terrible gangs are called *agbero* [touts] and they extort money from the drivers by force. The touts complain that they don't deserve their bad reputation: They're just doing their job. "As a 'motor parks official' I act as a tax collector," says Sulaimon Atere, 26. "I can't say that the tax we collect is legal or illegal. The touts are onetime drivers; since we are out of work, we must devise a way to earn a living. We have to be violent because drivers resist us when we approach them peaceably."

Lediglich zwölf von 1000 Nigerianern besitzen ein Auto. Das macht öffentliche Verkehrsmittel zum lukrativen Geschäft. „Das öf-fentliche Verkehrssystem wird hierzulande von Banden be-herrscht", erklärt Seye Solola, der in Lagos als Busfahrer arbeitet. Am schlimmsten seien die *Agbe-ro* (Anreißer), die den Fahrern mit Gewalt Geld abpressten. Die An-reißer meinen, sie hätten ihren schlechten Ruf nicht verdient: Sie täten nur ihre Arbeit. „Als ‚Beam-ter des Wagenparks' muss ich Steuern eintreiben", meint Sulai-mon Atere (26). „Ob die Steuern, die wir einziehen, dem Gesetz ent-sprechen oder nicht – das weiß ich nicht. Wir Anreißer sind ehemalige Fahrer, aber da wir arbeitslos sind, müssen wir uns halt irgendwie durchschlagen. Und Gewalt müs-sen wir anwenden, weil die Fahrer Widerstand leisten, wenn wir mit friedlichen Mitteln unserem Ge-schäft nachgehen."

Seuls douze Nigérians sur 1 000 possèdent une voiture, ce qui fait des transports publics une affai-re fort juteuse. « Ici, les transports sont aux mains des gangs », se désole Seye Solola, chauffeur de bus à Lagos. Les plus terribles, ce sont les *agbero* [rabatteurs], qui extorquent de l'argent aux chauf-feurs. Concert de protestations chez les rabatteurs en question, qui disent ne pas mériter leur mauvaise réputation. Ils ne font que leur travail, assurent-ils. « En tant que "responsable des aires de stationnement", j'ai en quelque sorte le rôle d'un per-cepteur, explique Sulaimon Ate-re, 26 ans. Je ne pourrais pas dire si les taxes [de stationne-ment] que nous prélevons sont lé-gales ou illégales. Tous les rabat-teurs sont eux-mêmes d'anciens chauffeurs. Comme nous n'avons plus de travail, il faut bien trouver un moyen de gagner sa vie. Et on est obligés d'être violents, parce que les chauffeurs nous ré-sistent quand on les approche pacifiquement. »

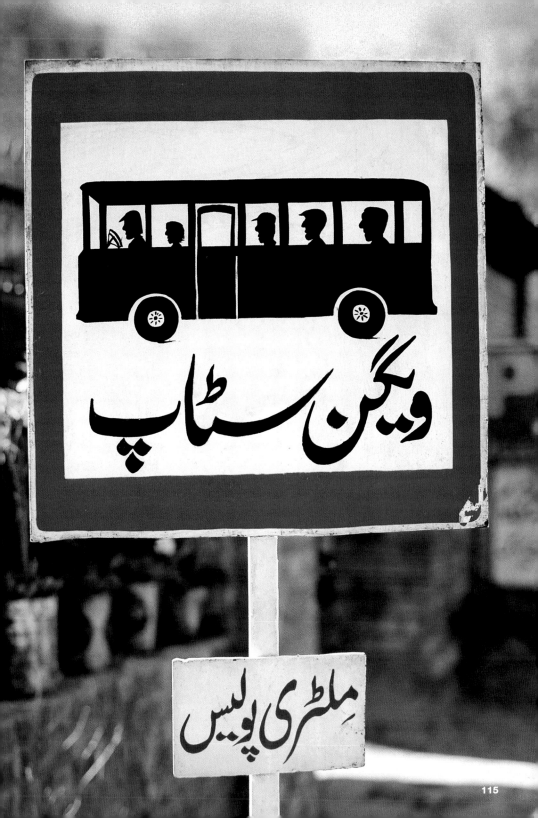

Reading material
Lesestoff
De quoi lire

One advantage of not driving is you have time to read. But what if you forget to your book? In Iceland, you don't have to worry as the National Publisher's Association supplies them (tied onto the back of seats to avoid theft) to read on your trip, while in Granada, Spain, booklets of prose, poetry and short stories are given out free on the city's buses. "Sitting in traffic on a bus makes you want to read," says Miguel Arcas, the director of the initiative. All the "bus books" are 60-pages long, designed to be finished during the city's average 40-minute, peak hour bus ride. Travelers are then asked to return the books to a special box near the driver's seat, although slower readers are also welcome to take them home.

Einer der vielen Vorteile einer Fahrt ohne eigenes Auto besteht darin, dass man Zeit zum Lesen hat. Und wenn du dein Buch zu Hause gelassen hast? In Island ist das kein Problem. Der nationale Verlegerverband stellt den Benutzern öffentlicher Verkehrmittel Bücher zur Verfügung (die an die Sitze gebunden sind, damit sie nicht gestohlen werden), während im spanischen Granada Bändchen mit Gedichten und Kurzgeschichten in städtischen Bussen gratis verteilt werden. „Wenn man in einem Bus im Verkehr festsitzt, bekommt man automatisch Lust zum Lesen", sagt der Leiter der Initiative, Miguel Arcas. Alle „Busbücher" haben 60 Seiten, die während einer Busfahrt – sie dauert in der Stoßzeit durchschnittlich 40 Minuten – durchgelesen werden können. Die Fahrgäste werden gebeten, die Bücher vor dem Aussteigen in einen Kasten neben dem Fahrersitz zu stecken, aber langsamere Leser dürfen die Bändchen auch mit nach Hause nehmen.

L'avantage, lorsqu'on ne conduit pas, c'est qu'on a le temps de lire. Mais que faire si on a oublié son livre? En Islande, pas de souci: l'Association nationale des éditeurs vous en fournit (attachés au dossier des sièges pour éviter les vols). Ne craignez donc plus de voyager idiots. De même, à Grenade (Espagne), de petits recueils de prose, de poésie ou de nouvelles sont distribués gratuitement dans les bus du secteur urbain. «Lorsqu'on se morfond dans un bus coincé dans les embouteillages, cela donne envie de lire», souligne Miguel Arcas, qui dirige l'initiative. Tous les «livres de bus», d'un format de 60 pages, sont calibrés pour être terminés en une quarantaine de minutes, ce qui correspond à la durée moyenne d'un trajet aux heures de pointe. Il est demandé ensuite aux usagers de déposer les ouvrages dans une boîte réservée à cet effet et placée près du siège du conducteur. Toutefois, les lecteurs plus lents sont libres d'emporter le livre pour le finir chez eux.

СТОЯТЬ БЛИЗКО К КРАЮ ПЛАТФОРМЫ

ОПАСНО!

Women only
Damenwagen
Réservé aux dames

Japanese railway companies have responded to complaints from women about unwelcome advances and drunken male behavior on trains by running women-only carriages on late night services. Keio Electric Railway Company and East Japan Railways both have cars reserved for female passengers on certain routes after 11pm on weeknights. Stickers on the trains and platforms announce—politely—that the carriages are strictly for women. Opinions are divided. Some applaud the segregation, while others see it as discrimination. East Japan Railways say that the response from female customers has been overwhelmingly positive and that they plan to continue the service.

Nach Klagen von Frauen über unerwünschte Annäherungsversuche und ungehobeltes Benehmen betrunkener männlicher Passagiere haben japanische Eisenbahngesellschaften bei Fahrten am späten Abend und nachts spezielle Waggons für Frauen eingerichtet. Bei der Keio Electric Railway Company sowie bei East Japan Railways gibt es die Frauenwaggons an Wochentagen auf bestimmten Strecken ab 23 Uhr. Aushänge auf Bahnsteigen und in den Zügen weisen höflich darauf hin, dass die Wagen ausschließlich Frauen vorbehalten sind. Die öffentliche Meinung ist geteilt. Die einen befürworten die Trennung, andere sprechen von Diskriminierung. Bei East Japan Railways heißt es, die weiblichen Fahrgäste hätten die Initiative positiv aufgenommen, der Service werde daher fortgeführt.

Inondées de plaintes émanant de femmes ayant eu à subir dans le train le harcèlement sexuel et les comportements douteux d'hommes en état d'ivresse, les compagnies ferroviaires japonaises ont trouvé la parade : elles ont instauré des wagons pour femmes dans tous les trains de nuit. Ainsi, la Compagnie de chemin de fer électrique Keio et les Chemins de fer de l'est du Japon réservent tous deux des wagons entiers à leurs « usagères » sur certains trajets, en semaine, après 23 heures. Des autocollants permettent de repérer les compartiments pour femmes, et des appels en gare annoncent – poliment – que tel et tel wagon est strictement réservé à ces dames. Les opinions sur le sujet restent très partagées : certains applaudissent cette séparation des sexes, tandis que d'autres y voient de la pure discrimination. Les Chemins de fer de l'est du Japon assurent de leur côté qu'ils ont eu un retour extrêmement positif de la part d'une vaste majorité de clientes, et qu'ils entendent bien maintenir ce dispositif.

Tired truckers
Übermüdete Trucker
Camionneurs épuisés

A third of fatal truck accidents are caused by fatigue (usually between 3am and 5am). So it's hardly surprising that staying awake is an obsession for most long-distance truckers. In Kenya many chew khat leaves, an illegal and addictive stimulant. Thai truck drivers prefer to smoke *ya maa*, a powerful amphetamine, even though possession of a single tablet can earn offenders a five-year prison sentence and a 50,000 baht (US$1,250) fine. Public safety, however, takes second place to the demands of the economy. "When I work I have to use it, otherwise I fall asleep," says Thon, 37, who drives trucks in northern Thailand during the sugarcane harvest, from December to March. He gets by on four to five hours of sleep a day. Though US regulations require truck drivers to sleep eight hours a day, the Thai authorities would rather not know. As Thon says, "The police wouldn't interfere, because the sugar is exported to foreign countries."

Ein Drittel aller tödlichen Lkw-Unfälle sind auf Übermüdung (die meist zwischen drei und fünf Uhr morgens auftritt) zurückzuführen. Von daher ist es verständlich, dass Wachbleiben für Langstrecken-Trucker zur fixen Idee werden kann. In Kenia kauen viele *khat*, ein illegales, Sucht erzeugendes Stimulans. Thailändische Fahrer verlassen sich auf *ya maa*, ein hochwirksames Amphetamin, auch wenn der Besitz einer einzigen Tablette mit fünf Jahren Haft und einer Geldbuße von 50 000 Baht (1250 US$) bestraft werden kann. Aber die öffentliche Sicherheit ist zweitrangig, wenn es um wirtschaftliche Interessen geht. „Wenn ich arbeite, muss ich das Zeug nehmen, sonst schlafe ich ein", erklärt Thon, 37, der während der Zuckerrohrernte von Dezember bis März in Nordthailand als Saisonarbeiter Lkw fährt. Er kommt mit vier bis fünf Stunden Schlaf aus. In den USA ist für Lkw-Fahrer eine tägliche Ruhezeit von acht Stunden vorgeschrieben, die thailändischen Behörden hingegen drücken oft beide Augen zu. Thon meint, die Polizei würde nicht eingreifen, weil der Zucker ins Ausland exportiert wird.

Un tiers des accidents de la route mortels impliquant des poids lourds sont imputables à la fatigue (la plupart surviennent entre trois et cinq heures du matin). Rien d'étonnant donc, si, pour les routiers effectuant de longs trajets, rester éveillé tourne à l'obsession. Au Kenya, beaucoup mâchent des feuilles de *qat*, un stimulant illégal entraînant une dépendance. Les camionneurs thaïlandais préfèrent fumer du *ya maa*, une puissante amphétamine, bien que la détention d'une tablette soit passible d'une peine de cinq ans et d'une amende de 50 000 BAHT (1 250 $ US). Cependant, les exigences économiques priment sur la sécurité publique. « Quand je travaille, je suis obligé d'en prendre, sinon je m'endors », confie Thon, 37 ans, qui transporte la canne à sucre dans le nord du pays en période de récolte (de décembre à mars). Et pour cause : il vit au régime de quatre à cinq heures de sommeil par nuit. Certes, la réglementation américaine exige des nuits de huit heures pour les chauffeurs routiers, mais les autorités thaïlandaises préfèrent l'ignorer. Comme dit Thon, « la police nous laisse faire, vu que le sucre est un produit d'exportation. »

不可阻塞

KEEP CLEAR

125

Danger: Tractors at work
Gefahr: Traktoren in Aktion
Attention aux tracteurs

Tractors are essential for many farmers and they look like fun to drive. Yet they're to blame for over 40 percent of farm deaths in the USA, so be careful. To help you out, here are some hints to safe driving:

1. A tractor's high center of gravity means that it rolls over easily—and 2,500 kilograms on top of you can be painful.

2. Watch out for the rotating power shaft (that thing that spins to power the wheels). Get too close, and before you know it, you'll be missing some fingers—or worse. An Indian safety manual discourages wearing loose-fitting clothing like *dhoti*, *kurta* and slippers when driving your machine, as they can easily get caught in the shafts and drag you in.

3. Watch your speed. You may want to drive quickly over bumpy terrain, across ditches and up steep slopes, but the fun stops if someone—maybe you—falls off and suffers nasty injuries.

4. Wear earplugs. Tractors are noisy, producing around 100 decibels—a plane taking off only produces 130 decibels—and extended exposure can lead to permanent hearing loss.

Happy driving!

Traktoren sind den meisten Landwirten unentbehrlich, und allem Anschein nach macht Treckerfahren Spaß. Doch leider sind in den USA über 40% aller Todesfälle auf Bauernhöfen auf Unfälle mit Treckern zurückzuführen, es ist also Vorsicht geboten. Hier ein paar Tipps für eine unfallfreie Fahrt:

1. Bei Traktoren liegt der Schwerpunkt eher hoch, daher kippen sie leicht um. Unter einen 2500 kg schweren Trecker zu geraten, kann für den Fahrer böse Folgen haben.

2. Hüte dich vor der Zapfwelle (das Ding, das sich dreht, um die Räder zum Rollen zu bringen). Wenn du ihr zu nahe kommst, bist du schnell ein paar Finger los. Aber es kann noch schlimmer kommen: In indischen Sicherheitsanweisungen wird davon abgeraten, beim Fahren lose Kleidung wie *dhotis*, *kurtas* oder Latschen zu tragen, die sich in der Zapfwelle verfangen und dich hineinziehen können.

3. Fahr nicht zu schnell. Mit Höchstgeschwindigkeit über unebenen Boden, durch Gräben oder steile Hänge hinauf zu brettern mag lustig sein, aber der Spaß hört auf, wenn jemand (du zum Beispiel) vom Trecker fällt und sich dabei ernsthaft verletzt.

4. Trag Ohrenpfropfen. Treckerlärm erreicht bis zu 130 Dezibel, das kann zu dauerhaften Hörschäden führen.

Gute Fahrt!

La plupart des agriculteurs ne sauraient se passer de leur tracteur, et ces engins ont l'air plutôt amusants à conduire. Aux États-Unis, ils sont pourtant la cause de 40 % des décès en milieu agricole. Aussi, soyez prudents. Voici quelques astuces pour une conduite sans risque :

1. Les tracteurs ont un centre de gravité très haut placé, si bien qu'ils se renversent facilement. Et 2 500 kilos sur le corps, c'est un peu douloureux.

2. Attention à l'arbre de transmission (le bidule qui entraîne la rotation des roues). N'approchez pas trop près, ou vous aurez quelques doigts de moins avant même de comprendre ce qui vous arrive. Un manuel de sécurité indien déconseille le port de pantoufles ou de vêtements trop amples, tels que le *dhoti* ou le *kurta*, au volant d'un tracteur, car ils peuvent facilement se prendre dans l'arbre de transmission, et vous serez alors irrémédiablement entraîné dans le moteur.

3. Surveillez votre vitesse. Oui, bien sûr, vous rêvez de rodéo, de foncer à toute allure sur un terrain bosselé, de franchir des fossés sans ralentir, d'escalader des talus abrupts, mais vous rirez moins lorsque quelqu'un vous, peut-être tombera du tracteur et se blessera très grièvement.

4. Portez des protections sur les oreilles. Les tracteurs sont des engins bruyants, qui produisent une centaine de décibels (alors qu'un avion au décollage ne dépasse pas les 130 décibels). Une exposition fréquente et prolongée à un tel vacarme peut occasionner des lésions auditives irréparables.

Bonne route !

Fuel efficient
Leistungsfähig
Energie renouvelable

Few things are more efficient than a bicycle. When you cycle, 80 percent of the energy you expend is turned into motion; by comparison, only 30 percent of the energy in a car's gas tank reaches the wheels. Bicycles improve the efficiency of the human body by 657 percent. You need 55.3 calories to walk at 6.4 kilometers per hour, so, on the energy provided by a plate of rice and beans, you could walk 7.5 kilometers—but you could cycle 49.3 kilometers. Cycling also provides an excellent form of cardiovascular exercise. According to research in the UK, a 20-minute ride to and from work, five days a week, cuts the risk of heart disease in half. And it could even make you a nicer person to work with—commuting by bicycle increases alertness, and lowers stress levels and frustration.

Fahrräder sind in Sachen Leistungsfähigkeit kaum zu schlagen. Beim Radfahren wird 80% der aufgewendeten Energie in Bewegung umgesetzt, während im Auto nur 30% der Energie im Tank die Räder erreicht. Radfahren erhöht die Leistungsfähigkeit des menschlichen Körpers sogar um 657%. Bei einem Fußmarsch mit einer Geschwindigkeit von 6,4 km/h verbraucht der Körper 55,3 Kalorien. Mit der Energie aus einem Teller Reis mit Bohnen könntest du demnach 7,5 km weit gehen, aber 49,3 km weit radeln. Radfahren ist außerdem nach britischen Studien ein ausgezeichneter Sport für das Herz: Wer fünf Tage die Woche 20 Minuten zur Arbeit und wieder nach Hause zu radelt, halbiert das Risiko einer Erkrankung am Herzen. Und du könntest auf diese Weise zu einem angenehmeren Kollegen werden: Das Radfahren zur Arbeit führt zu höherer Konzentrationsfähigkeit und zugleich zum Abbau von Stress und Frustration.

Difficile d'être plus efficace qu'une bicyclette. Pendant que vous pédalez, 80 % de l'énergie que vous dépensez est transformée en mouvement. Par comparaison, 30 % seulement de l'énergie stockée dans le réservoir d'une voiture est transformée en mouvement. Les vélos augmentent même de 657 % l'efficacité du corps humain. Pour marcher à la vitesse de 6,4 km/h, l'organisme brûle 55,3 calories, ce qui signifie qu'avec l'énergie procurée par un plat de riz et de haricots secs, vous pourriez marcher 7,5 km – alors qu'à vélo, vous pourriez parcourir 49,3 km. D'autre part, des recherches menées au Royaume-Uni ont prouvé que le vélo est un excellent exercice cardiovasculaire : un aller-retour quotidien de deux fois 20 minutes à bicyclette, entre votre lieu de travail et votre domicile, diminue de moitié le risque de problèmes cardiaques. Cela pourrait même vous rendre plus aimable et attrayant vis-à-vis de vos collègues. Aller travailler à vélo accentue en effet la vivacité d'esprit, tout en réduisant le stress et le sentiment de frustration.

Three-wheeler
Dreirad
Trois roues motrices

In Thailand, the tuk-tuk—named after the sound its engine makes—is the motorized rickshaw of choice. You can catch one of these brightly colored, traffic-weaving three-wheelers to anywhere in Bangkok for a price (careful negotiations may be necessary), but be on your guard. Keep your hands, legs and head inside the small cab and watch where you get taken. Most of the drivers—many from the northeast of Thailand—lease their tuk-tuks and need as many ways as possible to pay back the renter. Some may take you on a detour to a local shop where the driver will get a commission on what you spend. Despite tuk-tuks' two-stroke engines being noisy and polluting (and the Thai government's on-off attempts to ban them), they are proving popular abroad. Exported to Kenya, India, Vietnam and the city of Bath in the UK (where they're used for tourists), taking one home will cost you between US$1,900 and $2,500. And they make perfect presents: In 2001, the Thai prime minister gave one to Zimbabwe's president Robert Mugabe. He was reportedly thrilled with the gift.

Das Tuk-Tuk, benannt nach seinem typischen knatternden Motorengeräusch, ist in Thailand eines der beliebtesten Fortbewegungsmittel. Die bunten, dreirädrigen Motorrikschas flitzen wendig durch den Verkehr und bringen dich für einen fairen Preis – der allerdings vor Fahrtantritt ausgehandelt werden sollte – von einem Ende Bangkoks ans andere. Sei aber auf der Hut: Steck weder Kopf noch Hände oder Füße aus der Personenkabine und achte darauf, wo der Fahrer hinfährt. Die meisten Fahrer (viele kommen aus dem Nordosten des Landes) haben ihre Tuk-Tuks gemietet und wenden alle möglichen Mittel und Wege an, um die Miete aufzubringen. Manche machen einen kleinen Umweg zu Läden, in denen sie Provision auf die Summe bekommen, die ihr Fahrgast ausgibt. Obwohl die Zweitaktmotoren der Tuk-Tuks Lärm machen und wahre Dreckschleudern sind (weshalb die thailändische Regierung alle paar Jahre versucht, sie zu verbieten), sind sie im Ausland sehr beliebt. Tuk-Tuks wurden nach Kenia, Indien, Vietnam und ins englische Bath (auch dort werden sie vor allem von Touristen benutzt) exportiert und kosten zwischen 1900 und 2500 US$. Auch als Präsente sind sie bestens geeignet: 2001 beglückte der thailändische Premierminister den simbabwischen Präsidenten Robert Mugabe mit einem Tuk-Tuk. Der war von dem Geschenk begeistert.

En Thaïlande, le *tuk-tuk* – qui doit son nom au bruit caractéristique de son moteur – est un rickshaw motorisé de premier choix. Où que vous vous trouviez à Bangkok, vous pourrez prendre l'un de ces taxis bariolés à trois roues, qui n'ont pas leur pareil pour se faufiler entre les voitures et vous extirper des embouteillages. La course sera tarifée au juste prix, parfois à l'issue d'âpres négociations. Néanmoins, soyez sur vos gardes. Ne laissez pendre ni vos mains, ni vos jambes à l'extérieur de la petite cabine, et évitez de sortir la tête. De plus, faites attention à l'itinéraire que prend le conducteur. La plupart d'entre eux (beaucoup viennent du nord-est de la Thaïlande) ont acquis leur tuk-tuk en leasing et, pris à la gorge par les traites du loueur, ils font feu de tout bois pour arrondir leurs revenus. Plus d'un vous fera donc faire un détour par une boutique locale qui lui versera une commission sur vos achats. Bien que les moteurs à deux temps des tuk-tuk soient bruyants et polluants (et malgré les velléités sporadiques du gouvernement thaïlandais, qui songe régulièrement à les interdire), leur popularité est telle qu'ils se répandent hors des frontières du pays. Exportés vers le Kenya, l'Inde, le Viêt Nam et la ville de Bath, au Royaume-Uni (où ils servent, là aussi, au transport des touristes), ils vous coûteront entre 1 900 et 2 500 $ US pièce s'il vous prend l'idée d'en ramener un chez vous. Un cadeau à faire ? Pas de meilleure idée ! En 2001, le Premier ministre thaïlandais en a offert un au président du Zimbabwe, Robert Mugabe, qui fut, paraît-il, transporté de joie.

Take away
Napfträger
Plats à emporter

It's lunchtime in the offices of Ernst & Young in Mumbai, India, and accountant Pradyumna Agrawal, 25, is taking a break to eat a home-cooked meal. Over 175,000 lunches are delivered to Mumbai offices every day by the city's network of 5,000 *dubbawallahs* or tiffin-carriers (named after the tiffins or lunch pails that food is transported in). Carriers collect the meal from a worker's home, pass it on to other carriers at meeting points such as railway stations, and then collect the tin and take it home again—all for Rs200 (US$4) a month. No documents are kept, but tiffin mix-ups are rare because the carriers use a simple coded system to keep track of their cans. "My mother just would not allow me to have my meals in a restaurant," says Pradyumna. "She thinks it's not healthy. We have a cook at home and my lunch is delivered by dubbawallahs with great care and punctuality. I get to eat my home-cooked food in the comfort of the office. My tiffin is envied by my colleagues, especially during festivals when there are delicacies."

Bei Ernst & Young im indischen Bombay ist Mittagszeit. Buchhalter Pradyumna Agrawal (25) nutzt die Pause, um eine zu Hause zubereitete Mahlzeit zu sich zu nehmen. Über 175 000 Mittagessen werden täglich von einem Netz von 5000 *dubbawallahs* oder Napfträgern (benannt nach dem Napf oder Henkelmann, in dem das Essen transportiert wird) in die Büros von Bombay geliefert. Der *dubbawallah* holt die Mahlzeit aus der Wohnung des Angestellten, gibt sie an bestimmten Treffpunkten wie zum Beispiel Bahnhöfen an andere Träger weiter, holt anschließend das Essgeschirr wieder ab und bringt es zurück nach Hause – für ganze 200 Rupien (4 US$) pro Monat. Obwohl nichts schriftlich festgelegt ist, sind Verwechslungen äußerst selten, weil die Träger ein einfaches Codesystem benutzen, um die Behälter zu identifizieren. „Meine Mutter würde mir nie erlauben, ins Restaurant zu gehen", erklärt Pradyumna. „Sie findet das ungesund. Zu Hause haben wir einen Koch, und die *dubbawallahs*, die mir mein Essen bringen, machen ihre Arbeit gut und sind pünktlich. So kann ich bequem im Büro essen wie zu Hause. Meine Kollegen sind alle neidisch, vor allem an Festtagen, wenn meine Mutter mir etwas besonders Leckeres schickt."

Pause-déjeuner dans les bureaux d'Ernst & Young, à Mumbai (Inde). Le comptable Pradyumna Agrawal, 25 ans, s'apprête à déguster sur son lieu de travail un repas fait maison. Plus de 175 000 déjeuners sont ainsi livrés chaque jour dans les bureaux de Mumbai, par les soins de 5 000 *dubbawallahs* ou livreurs de *tiffins* («repas de midi» en anglo-indien, dérivé du mot indien *tiffin*, qui désigne la gamelle métallique dans laquelle les plats sont transportés). Les porteurs vont chercher ces paniers-repas au domicile du client, les passent en relais à d'autres livreurs qu'ils retrouvent à des points de rendez-vous précis, dans les gares par exemple, puis récupèrent les gamelles vides et les ramènent chez le client – le tout pour 200 RUPI (4 $ US) par mois. Rien ne passe par l'écrit, et pourtant les échanges accidentels de tiffins sont chose rare, car les porteurs utilisent un codage simple et efficace pour s'assurer de retrouver les leurs. «Ma mère ne permettrait pas que je prenne mes repas au restaurant, se récrie Pradyumna. Elle trouve que ce n'est pas sain. Nous avons un cuisinier à la maison, et les dubbawallahs me livrent avec beaucoup de soin et de ponctualité. Comme ça, je peux manger un repas maison bien à mon aise, dans mon bureau. Mes collègues m'envient, surtout au moment des fêtes, quand ma mère m'envoie plein de bonnes choses.»

139
Children
Kinder
Enfants

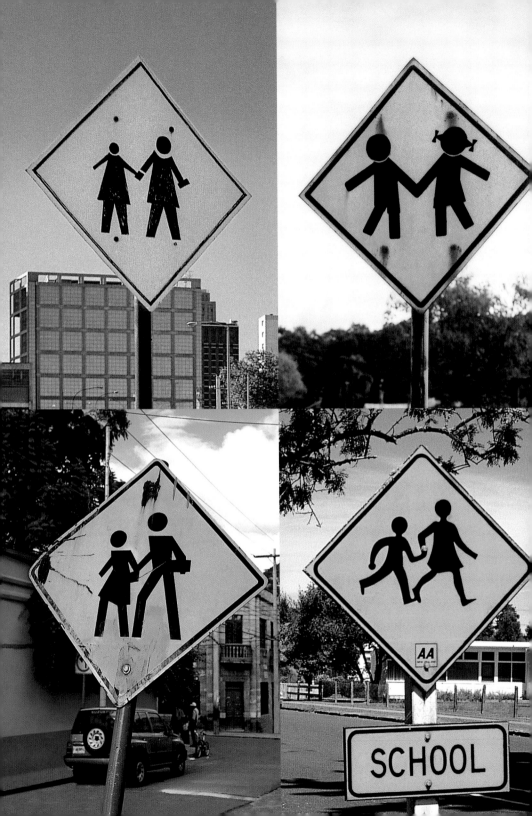

SCHOOL

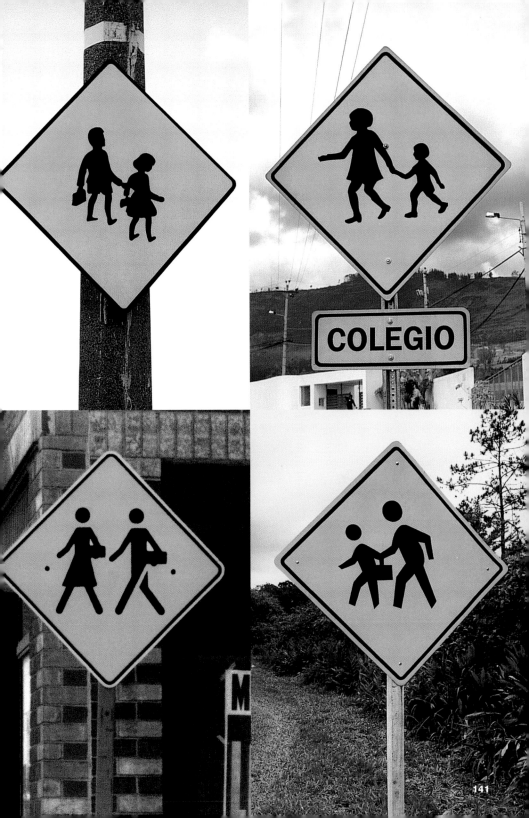

COLÉGIO

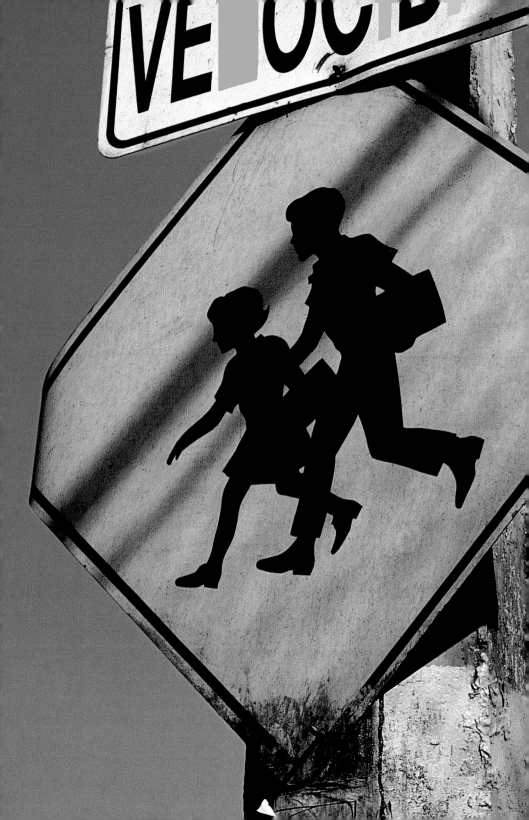

One child
Einzelkind
Enfant unique

Show off your status in China, by going for a walk with your two children. To keep the world's biggest population in check, couples there have been limited to one child since 1979. Most hope for a baby boy. Doctors are prohibited from revealing the fetus' sex during ultrasound tests, but a gift of cigarettes often wins them over, if US newspaper reports are to be believed. If the doctor smiles, the expectant mother knows it's a boy. If he frowns, it's a girl, and the mother can abort and try again. The State Family Planning Commission makes some exceptions (among ethnic minorities, for example) but most two-child families are fined a "social compensation tax." And usually it's steep—a quarter of the parents' salary for five years. "I've been punished: I had to pay more than 30,000 yuan [US$3,628]," says Shi Yu, 39, a father of two in Kunming. "Most people can't afford a sum that big." But the prestige might be worth the financial hardship. "I have felt the admiration of others."

Wenn du in China zeigen willst, dass du etwas Besseres bist, geh einfach mit deinen beiden Kindern spazieren. Damit die Einwohnerzahl in dem bevölkerungsreichsten Land der Welt nicht noch weiter wächst, dürfen Paare dort seit 1979 nur noch ein Kind haben. Die meisten hoffen auf einen Jungen. Ärzte dürfen bei Ultraschalluntersuchungen das Geschlecht des Babys nicht preisgeben, aber nach amerikanischen Zeitungsberichten kann man sie oft mit einer Stange Zigaretten dazu bewegen, es doch zu tun. Wenn der Arzt lächelt, weiß die werdende Mutter, dass sie einen Jungen bekommt; runzelt er die Stirn, ist es ein Mädchen. In diesem Fall kann die Mutter eine Abtreibung vornehmen lassen und ihr Glück noch einmal versuchen. Die staatliche Familienplanungskommission macht vereinzelt Ausnahmen (zum Beispiel bei ethnischen Minderheiten), aber normalerweise bekommen Familien mit zwei Kindern eine happige „Kompensationssteuer" aufgebrummt und müssen fünf Jahre lang ein Viertel des Gehalts der Eltern an den Staat abführen. „Ich wurde hart bestraft: Über 30 000 Yuan (3628 US$) haben sie mir abgenommen", sagt Shi Yu (39), Vater von zwei Kindern in Kunming. „Eine solche Summe kann der Durchschnittsbürger nicht aufbringen." Aber das Prestige, das zwei Kinder mit sich bringen, ist mit Geld nicht aufzuwiegen. „Ich merke, wie sehr mich die anderen bewundern."

Pour sortir du lot en Chine, allez promener en ville votre paire de rejetons. Afin de limiter la croissance démographique du pays le plus peuplé au monde, les couples chinois n'ont plus droit qu'à un seul enfant depuis 1979. La plupart souhaitent bien entendu un garçon. Or, s'il est interdit aux médecins de révéler le sexe de l'enfant lors des échographies, un don de cigarettes a souvent raison de leur réticence – nous apprennent plusieurs reportages dans la presse écrite américaine. Si le docteur sourit, c'est un garçon, s'il fronce les sourcils, c'est une fille. Libre alors à la future mère d'avorter et de tenter à nouveau sa chance. Certes, la Commission d'État de planning familial tolère quelques exceptions à la règle de l'enfant unique (en particulier au sein des minorités ethniques). Néanmoins, la plupart des familles de deux enfants se voient prélever un «impôt social compensatoire», d'ordinaire exorbitant, puisqu'il les prive d'un quart de leurs revenus pendant cinq ans. «J'ai moi-même été puni, nous dit Shi Yu, 39 ans, père de deux enfants à Kunming. J'ai dû verser plus de 30000Y [3628 $US]. Ce n'est pas à la portée du tout-venant.» Pourtant, le prestige acquis vaut bien le sacrifice. «J'ai senti l'admiration des gens autour de moi.»

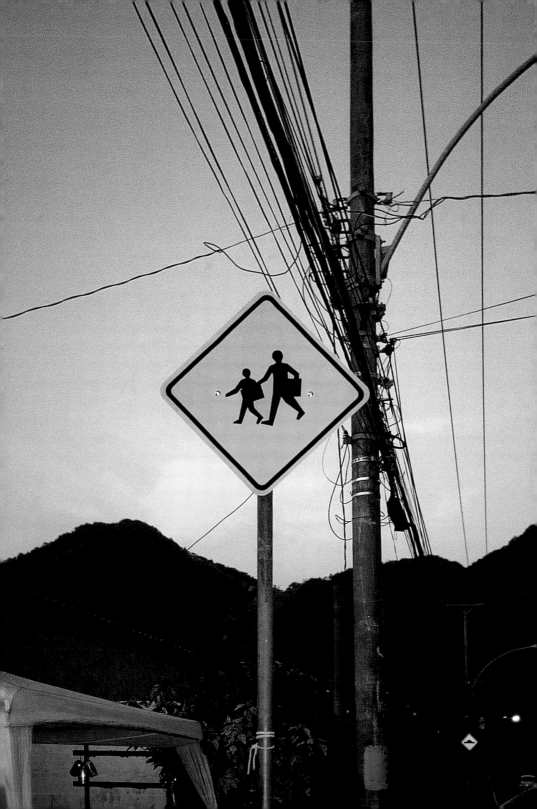

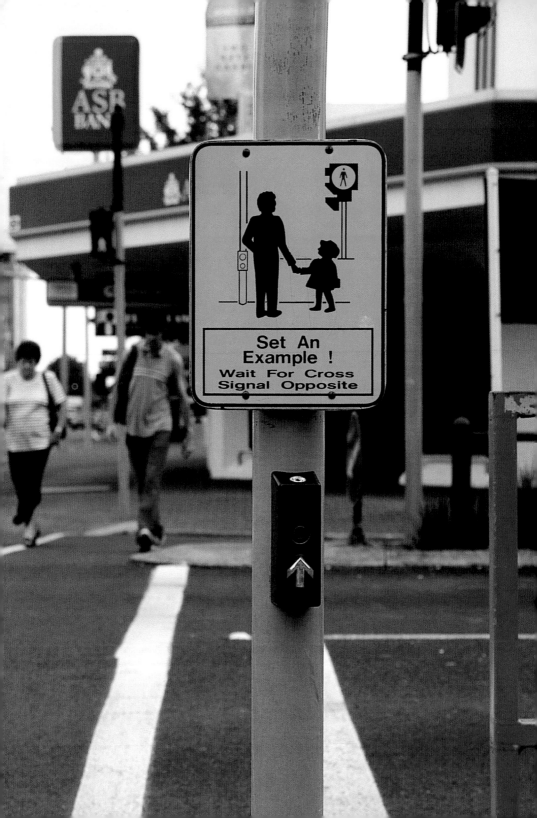

Child prodigies
Wunderkinder
Enfants prodiges

At the age of two, thousands of Japanese toddlers begin studying to gain entry to one of Tokyo's 23 elite kindergartens. The children attend *juku* (cram schools), where they are groomed for an entrance exam and interview. "It's a definite plus if the child is able to hold chopsticks properly and eat in a polite, attractive manner," says Hideo Ohori, president of the Shingaka (Growing Buds Society), an organization of 18 prestigious cram schools in and around Tokyo. "We have a saying here, 'A child who uses chopsticks correctly will learn to write correctly.'" But it's not just the kids who learn—their parents also receive tutoring. According to Hideo, the mother should wear conservative designer clothes and support her husband in everything he says. But despite the effort and the expense—some parents are willing to pay tuition fees of around ¥730,000 (US$6,700) a year—there's no guarantee that a child can join the elite. Only 12 percent of toddlers make the grade.

Mit zwei Jahren fangen Tausende japanischer Kinder an, für die Aufnahme in einem der 23 Elitekindergärten in Tokio zu büffeln. Die Kinder werden in speziellen *juku* (Paukschulen) auf die Aufnahmeprüfung und das Vorstellungsgespräch getrimmt. „Ein absoluter Pluspunkt ist, wenn ein Kind seine Essstäbchen richtig hält und schön sauber isst", sagt Hideo Ohori, Direktor der Shingaka (Gesellschaft der prallen Knospen), der 18 führende Paukschulen in und um Tokio angehören. „Bei uns heißt es: ‚Ein Kind, das die Stäbchen korrekt hält, lernt später korrekt zu schreiben.'" Aber nicht nur die Kinder lernen etwas – auch ihre Eltern bekommen so manche Lektion. Hideo meint, Mütter sollten konservative Designerkleidung tragen und ihren Männern immer und unter allen Umständen Recht geben. Aber die ganze Mühe und die saftigen Gebühren – 730 000 Yen (6700 US$) im Jahr – sind keine Garantie für einen Aufstieg in die Elite: Nur 12 % aller Kinder schaffen die Aufnahme.

Dès l'âge de deux ans, des milliers de bambins japonais commencent leurs études sur les chapeaux de roues, en préparant le concours d'accès à l'une des 23 maternelles d'élite de Tokyo. Des *juku* (instituts préparatoires) les accueillent et les forment en vue des épreuves et de l'entretien. «Si l'enfant tient bien ses baguettes, s'il mange proprement et avec élégance, cela représente un plus indéniable», souligne Hideo Ohori, président de Shingaka (association des écoliers en herbe), organisme regroupant 18 instituts préparatoires de prestige dans la capitale et ses environs. «Ici, poursuit-il, nous avons un dicton. "Un enfant qui manie bien ses baguettes maniera bien sa plume."» Du reste, les jeunes pousses ne sont pas seules à apprendre : les parents eux aussi reçoivent des cours de soutien. Selon Hideo, la mère doit s'habiller bon chic bon genre et toujours abonder dans le sens de son mari. Mais malgré tous les efforts consentis et les frais encourus sans sourciller (environ 730000 ¥, soit 6 700 $ US par an), rien ne garantit que l'enfant rejoigne les rangs de l'élite : seuls 12 % d'entre eux seront admis.

Night school
Abendschule
Cours du soir

More than 250 million children worldwide work in order to live. Half of them also manage to get some kind of education—usually after a full day's labor. In India, night schools for working children are government-funded. Headaches, sore eyes and exhaustion are common, but teachers are sympathetic. "If I am late the teachers don't scold me, they understand my problems," says Hemlata Kohli, 16, who works in a clinic by day and then attends night school in downtown Mumbai. Fellow student Bharat Kohli, 18, admits he rarely gets more than four hours' sleep, but says, "If I concentrate too much on my health, who will take care of the financial problems at home?"

250 Millionen Kinder weltweit müssen durch Arbeit für ihren Lebensunterhalt sorgen. Die Hälfte geht zusätzlich noch zur Schule, normalerweise nach einem vollen Arbeitstag. In Indien werden Abendschulen für arbeitende Kinder staatlich gefördert. Kopfschmerzen, rote Augen und Erschöpfung sind normal, aber die Lehrer zeigen viel Verständnis: „Wenn ich mal zu spät komme, sagen die Lehrer nichts. Sie wissen, welche Probleme wir haben", erklärt Hemlata Kohli (16), die tagsüber in einer Klinik arbeitet und eine Abendschule im Zentrum von Mumbai besucht. Ihr Mitschüler Bharat Kohli (18) gibt zu, dass er selten mehr als vier Stunden Schlaf pro Nacht bekommt, meint aber: „Wenn ich zu sehr auf mein eigenes Wohlergehen bedacht bin, wer bringt dann das Geld nach Hause?"

Plus de 250 millions d'enfants dans le monde doivent travailler pour vivre. La moitié d'entre eux parviennent néanmoins à fréquenter une forme ou une autre d'école – généralement après une lourde journée de labeur. En Inde, les cours du soir pour enfants qui travaillent sont subventionnés par l'État. Les migraines, les yeux qui brûlent et l'épuisement sont monnaie courante, mais les enseignants se montrent compréhensifs. «Si je suis en retard, les professeurs ne me disent rien – ils comprennent mes problèmes», assure Hemlata Kohli, 16 ans, qui travaille le jour dans une clinique, puis court à l'école le soir dans le centre-ville de Mumbai. Son camarade de classe Bharat Kohli, 18 ans, admet qu'il dort rarement plus de quatre heures par nuit, mais il ajoute : « Si je m'inquiète trop de ma santé, qui s'occupera des problèmes d'argent chez moi ? »

School lunch
Schulspeisung
Tous à la cantine !

Slips left in a school lunch suggestion box in Oakwood Friends School in Poughkeepsie, USA, called for more barbecued chicken wings, grilled cheese and french fries. During the 2001-2002 economic crisis in Argentina, schoolchildren were given fewer menu choices. The crisis, which sent the currency crashing and inflation rates soaring, meant that unknown numbers of families went hungry. "Many provinces decided to keep school lunchrooms open for weekends and over the summer," Mariano Mohadeb, a spokesman for the Argentine Ministry of Education, said at the time, "because so many kids are going to school not only to study but also to eat. It's the only place they can get food." The Ministry freed up 5 million pesos (US$1.7 million) to pay for the school feeding program in 10 provinces, believing it would help around 800,000 children in 6,000 schools. "Schools have always played an enormous role in society," said Mohadeb. "In this time of crisis, they are playing a bigger role than ever."

An der Oakwood-Friends-Schule in Poughkeepsie (USA) hätten die Schüler – wie aus ihren Wunschzetteln für die Schulspeisung hervorgeht – zum Mittagessen gern mehr Barbecue-Hühnerflügel, gegrillten Käse und Pommes frites. In Argentinien hatten die Schülerinnen und Schüler während der Wirtschaftskrise 2001-2002 weniger Auswahl. Die Krise, die die Währung ins Bodenlose fallen ließ, während die Inflation himmelhoch stieg, führte dazu, dass zahlreiche argentinische Familien Hunger litten. „In vielen Provinzen blieben die Schulkantinen auch an Wochenenden und in den Sommerferien geöffnet", erklärte Mariano Mohadeb vom argentinischen Kultusministerium, „weil viele Kinder nicht nur zum Lernen in die Schule gehen, sondern auch zum Essen. Nur dort bekommen sie eine warme Mahlzeit." Das Ministerium stellte für das Schulspeisungsprogramm in zehn Provinzen 5 Millionen Pesos (1,7 Millionen US$) zur Verfügung, um damit schätzungsweise 800 000 Kindern in 6000 Schulen zu helfen. „Schulen spielen seit jeher eine bedeutende Rolle in der Gesellschaft", meint Mariano. „In der gegenwärtigen Krisensituation sind sie wichtiger denn je."

Les petits mots glissés dans la boîte à idées « cantine » de l'école Oakwood Friends de Poughkeepsie (États-Unis) réclamaient invariablement plus de poulet au barbecue, plus de fromage grillé ou plus de frites. Durant la crise économique que traversa l'Argentine en 2001–2002, les écoliers n'avaient pas autant de choix au menu. Avec une monnaie au plus bas et une inflation galopante, la faim était devenue une réalité quotidienne pour un nombre important – et indéterminé – de familles. « De nombreuses provinces ont décidé de maintenir les cantines des écoles ouvertes les weekends et pendant l'été, nous signalait à l'époque Mariano Mohadeb, du ministère argentin de l'Éducation, parce que beaucoup d'enfants à présent vont à l'école non seulement pour s'instruire, mais aussi pour manger. C'est le seul endroit où ils sont assurés d'être nourris. » Ledit ministère avait débloqué 5 millions de pesos (1,7 million $ US) afin de financer dans 10 provinces ces repas de cantine, escomptant secourir ainsi 800 000 enfants dans 6 000 établissements scolaires. « L'école a toujours joué un rôle capital dans la société, soulignait Mariano. En ce temps de crise, sa mission est plus importante que jamais. »

GM.P

12 HRS 07 TO 20-30

157

Danger for children
Kinder in Gefahr
Éloignez les enfants

"I went to a nearby village to trade maize for salt. I left my older children with my sister and took the baby girl on my back. I'd come on foot, taking the paths across the fields. After I got my salt and cooking oil, I was tired so I got on the truck. Halfway, there was an explosion. A big noise. When I woke up I was in the hospital in Kuito. Both my legs were gone. My baby was dead. Eight others in the truck died. The truck had hit an antitank land mine. It was a new one too, because trucks use that road frequently. Why do they use land mines? This happens all the time. Soon every adult in the country will be an amputee and every child will die. I don't know why the government and UNITA [rebel forces] are fighting. Only politicians know why. All I know is that my baby did not have to die and I did not have to lose my legs. This is not our war." In 1999, Adriana Ribeiro's infant daughter was killed by one of the estimated 10 million land mines planted in Angola.

„Ich ging ins Nachbardorf, um dort Mais gegen Salz zu tauschen. Die älteren Kinder ließ ich bei meiner Schwester zurück, mein kleines Mädchen band ich mir auf den Rücken. Nachdem ich Salz und Speiseöl bekommen hatte, wollte ich per Anhalter nach Hause fahren. Auf dem Hinweg war ich zu Fuß über die Felder gelaufen, aber ich war müde, also stieg ich auf einen Laster. Auf halbem Wege gab es einen Riesenknall. Als ich wieder aufwachte, lag ich im Krankenhaus in Kuito. Meine Beine waren weg, und mein Baby war tot. Acht weitere Personen auf dem Laster waren ebenfalls ums Leben gekommen. Der Lkw war über eine Anti-Panzermine gefahren. Sie muss neu gelegt worden sein, denn auf dieser Strecke sind häufig Lkws unterwegs. Warum legen die Leute bloß diese Minen? So etwas passiert immerzu. Bald sind hier alle Erwachsenen Krüppel und alle Kinder tot. Ich weiß nicht, warum sich die Regierung und die UNITA-Rebellen bekämpfen. Das verstehen nur die Politiker. Ich weiß nur, dass mein Baby nicht hätte sterben müssen und dass ich noch zwei gesunde Beine haben könnte. Dieser Krieg geht uns nichts an." Adriana Ribeiros kleine Tochter wurde 1999 von einer der schätzungsweise 10 Millionen Landminen in Angola getötet.

« Ce jour-là, j'étais allée dans un village voisin pour troquer du maïs contre du sel. J'avais laissé mes enfants à ma sœur, sauf la dernière, que j'avais sur mon dos. Quand j'ai eu mon sel et mon huile, j'ai demandé à un camion de me ramener. J'étais venue à pied, par des sentiers à travers champs, mais j'étais fatiguée, alors je suis montée dans ce camion. À mi-chemin, il y a eu une explosion. Un bruit terrible. Quand je me suis réveillée, j'étais à l'hôpital de Kuito, avec les deux jambes en moins. Mon bébé était mort, avec huit autres passagers dans le camion. Il avait heurté une mine antichar. Elle ne devait pas être là depuis longtemps, car cette route est très fréquentée. Pourquoi est-ce qu'ils posent des mines ? Ces choses-là, ça arrive tout le temps. Bientôt, tous les adultes ici seront amputés, et tous les enfants morts. Je ne sais pas pourquoi le gouvernement et [les rebelles de] l'UNITA se battent. Ça, il n'y a que les hommes politiques qui le savent. Tout ce que je sais, c'est que mon bébé n'avait pas à mourir, ni moi à perdre mes jambes. Cette guerre, ce n'est pas la nôtre. » En 1999, la fillette âgée de quelques mois d'Adriana Ribeiro a été tuée par une mine terrestre ; 10 million d'autres trufferaient encore le sol angolais.

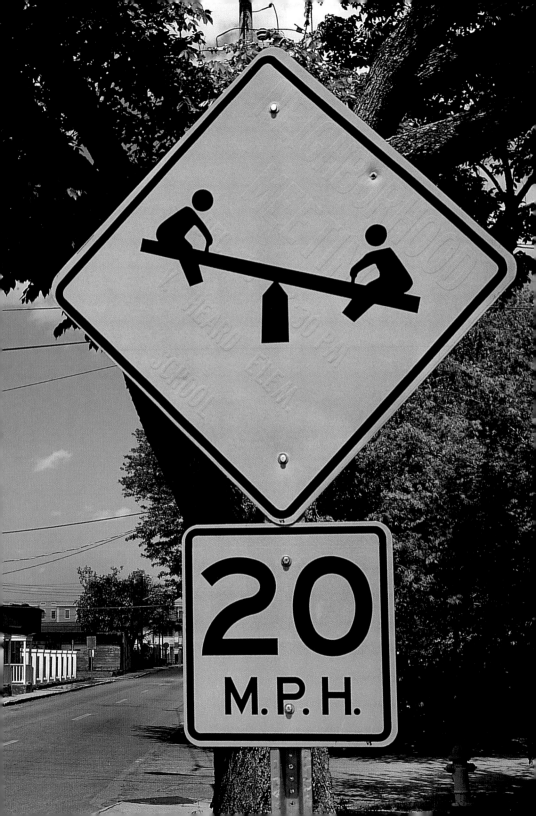

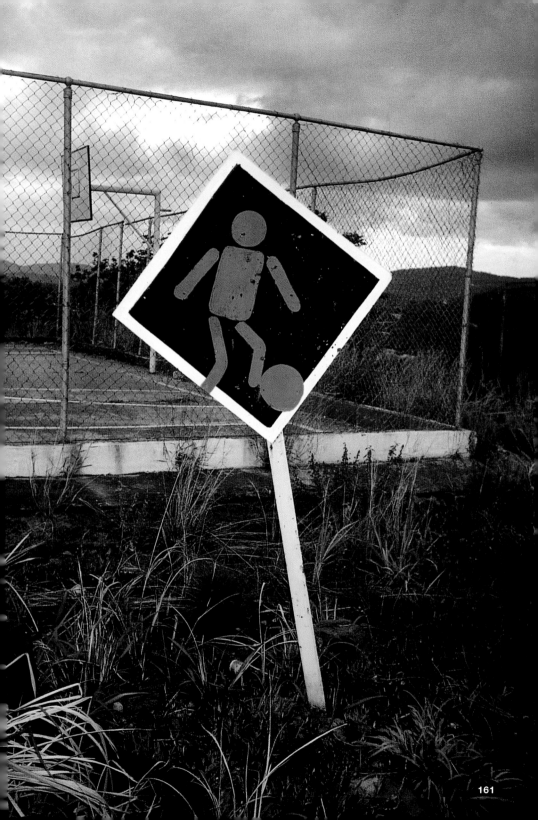

163
Miscellaneous
Verschiedenes
En vrac

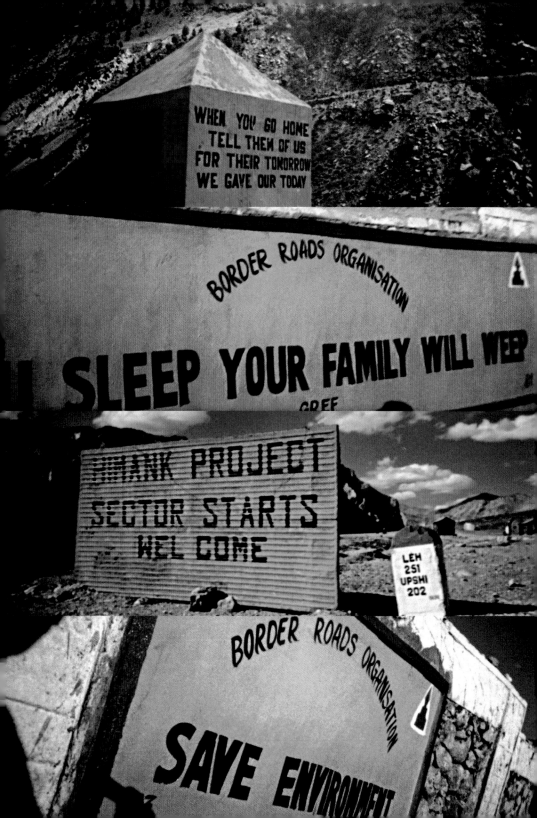

Handmade
Handarbeit
Fait main

"**We** were given two months to produce handmade signs. The Salang Tunnel was a priority because it was so dangerous. People die there every year, because when trucks break down, everyone keeps their motor running; and people end up dying of asphyxiation. I worked with some designers, a painter and a metalworker. The painter, Aleph, was a renowned watercolor artist before the war. There were no signs left in Afghanistan, except those put up by NGOs and the military, mostly land mine and bomb warnings. At first they asked me to design a sheep, but the Afghans refused to be compared to sheep. They wanted a bearded man, which was too morose, so I designed the new *habib* (mascot). I adapted my style to the Afghans'—we couldn't use too many colors or complex shapes. Unfortunately, there weren't enough funds so we could only make small 2m by 2m signs, which aren't very useful in the snow-covered mountains of the Salang." Stéphane Perraud was contracted by the Afghan government and an NGO to design signs for the Soviet-built Salang Tunnel in Afghanistan.

„**Wir** hatten zwei Monate Zeit, die Schilder von Hand herzustellen. Die Beschilderung des Salang-Tunnels war am wichtigsten, weil er so gefährlich ist. Darin sind immer wieder Menschen ums Leben gekommen: Wenn ein Lkw im Tunnel liegen blieb, bildete sich eine Autoschlange, niemand stellte den Motor ab, und die Insassen erstickten an den Abgasen. Ich habe mit ein paar Zeichnern, einem Maler und einem Schweißer zusammengearbeitet. Der Maler, Aleph, war vor dem Krieg ein bekannter Aquarellist. In ganz Afghanistan gab es keine Verkehrsschilder mehr außer denen, die NGOs und das Militär aufstellten, vorwiegend Bomben- und Minenwarnungen. Zuerst wollten sie, dass ich ein Schild mit einem Schaf male, aber die Afghanen wollten nicht mit Schafen verglichen werden. Dann wollten sie einen bärtigen Mann, aber der sah zu griesgrämig aus, und so entwarf ich das neue *Habib* (Maskottchen). Meinen Stil passte ich dem afghanischen Geschmack an – nicht zu viele Farben oder zu komplizierte Formen. Leider hatten wir nur Geld für relativ kleine, 2 x 2 m große Schilder, die in den schneebedeckten Salang-Bergen nicht optimal zur Geltung kommen." Stéphane Perraud wurde von der afghanischen Regierung und einer NGO beauftragt, für den von den Russen angelegten Salang-Tunnel in Afghanistan Schilder zu entwerfen.

« **Nous** avions deux mois pour fabriquer des panneaux de nos propres mains. Le tunnel de Salang était si dangereux qu'il était devenu une priorité. Tous les ans, il y avait des morts parce que, lorsqu'un camion tombait en panne, personne n'éteignait son moteur, et ils mouraient asphyxiés. J'ai travaillé avec des designers, un peintre et un ferronnier. Le peintre, Aleph, avait été un aquarelliste de renom avant la guerre. Il ne restait plus un seul panneau de signalisation en Afghanistan, à part ceux posés par les ONG et par l'armée – la plupart pour signaler des champs de mines ou des bombes non désamorcées. Tout d'abord, on m'a demandé de dessiner un mouton, mais les Afghans ont refusé d'être comparés à de vulgaires moutons. Ils réclamaient un homme barbu. Je trouvais ça tristounet, alors j'ai créé la nouvelle *habib* (mascotte). J'ai adapté mon style aux Afghans – pas trop de couleurs ni de formes trop complexes. Malheureusement, les fonds manquaient, si bien que nous avons dû nous contenter de petits panneaux de 2 x 2 m, ce qui n'est pas très utile dans les montagnes enneigées qu'on traverse pour accéder au Salang. » Stéphane Perraud a été commissionné par le gouvernement afghan, associé à une ONG, pour concevoir des panneaux de signalisation destinés au tunnel de Salang, bâti par les Soviétiques en Afghanistan.

ห.จ.ก.สามประสิทธิ์

Rua sem saída

Keep moving
Verkehr
Circulez

Keeping traffic flowing is vital to the economy of modern cities. It saves money (US companies lose US$25 billion a year through employees delayed by morning traffic jams); it saves time (the average British motorist spends a total of five full days a year stuck in traffic); and it reduces stress. So if you're thinking of becoming a traffic cop, head for the big city. (Take a face-mask—traffic cops in many cities suffer carbon monoxide poisoning.) For a challenge, consider a job in Bangkok, the world's most congested city. Four-hour commutes are common in the booming Thai capital, and an estimated 300-400 new cars hit the streets each day. To cope with the problem, Bangkok's traffic cops have taken to dancing in the streets. "Desperate situations require desperate measures," says Police Major Dusit Somsak, who created the technique. The freestyle movements—which range from somersaults to ballet steps—are said to entertain motorists and draw more attention to the officers' directions.

Für moderne Städte und ihre Wirtschaft ist es lebenswichtig, dass der Verkehr im Fluss bleibt. Das spart Geld (US-Unternehmen verlieren jährlich 25 Milliarden US$, weil ihre Angestellten wegen morgendlicher Staus zu spät ins Büro kommen) und Zeit (der britische Autofahrer steckt im Jahr durchschnittlich fünf Tage im Verkehr fest) und baut Stress ab. Wenn du also eine Karriere als Verkehrspolizist in Erwägung ziehst, lass dich in einer möglichst großen Stadt nieder (aber vergiss die Gasmaske nicht – in vielen Städten leiden Verkehrspolizisten an Kohlenmonoxidvergiftung). Eine echte Herausforderung ist Bangkok, die Stadt mit den am stärksten verstopften Straßen weltweit. Für Pendler in der boomenden thailändischen Metropole sind Fahrten zur Arbeit von vier Stunden die Regel, und täglich kommen etwa 300 bis 400 zusätzliche Autos auf die Straßen. Um das Problem in den Griff zu bekommen, regeln Polizisten in Bangkok neuerdings tanzend den Verkehr. „Extremsituationen erfordern radikale Maßnahmen", erklärt der Polizeibeamte Dusit Somsak, der die Technik erfand. Der überaus kreative Polizistentanz schließt vom Purzelbaum bis zu Anregungen aus dem klassischen Ballett nichts aus, was die Verkehrsteilnehmer unterhalten und ihre Aufmerksamkeit auf die Anweisungen des Polizisten ziehen könnte.

Il est vital pour l'économie des agglomérations modernes d'assurer une circulation fluide. Cela représente une économie d'argent (les entreprises américaines perdent 25 milliards $ US par an en raison des retards d'employés coincés dans les embouteillages), un gain de temps (un automobiliste britannique passe en moyenne cinq jours entiers par an dans les bouchons), et un facteur de stress en moins. Donc, si vous êtes tenté par le métier d'agent de la circulation, partez vivre dans une grande métropole (mais prévoyez un masque à gaz : dans de nombreuses villes, les préposés souffrent d'intoxication au monoxyde de carbone). Et si vous aimez les défis, optez pour Bangkok, l'agglomération la plus congestionnée au monde. Dans la capitale thaï en plein essor, il n'est pas rare de passer quatre heures en trajets quotidiens entre sa maison et son lieu de travail et, selon les estimations, 300 à 400 voitures neuves seraient lâchées dans les rues chaque jour. Pour faire face à une telle situation, les agents de la circulation de Bangkok se sont mis à danser dans les rues. « À situations désespérées, remèdes désespérés », résume l'officier supérieur de police Dusit Somsak, qui a mis au point cette technique. Il semblerait qu'outre leur caractère divertissant, non négligeable pour le conducteur, ces enchaînements de style très libre – allant du saut périlleux à certains pas de danse classique – attirent mieux l'attention sur les directives des agents.

181
Danger
Gefahr
Danger

Last meal
Letzte Mahlzeit
Dernier repas

At 4.30pm on May 30, 2002, Stanley Allison Baker Jr. began eating two 500g rib eye steaks, 450g of thinly sliced turkey, 12 rashers of bacon, two hamburgers with mayonnaise, onion and lettuce, two large baked potatoes with butter, sour cream, cheese and chives, four slices of cheese, a chef salad with blue-cheese dressing, two ears of corn, and one tub of mint chocolate chip ice cream. He drank four vanilla Coca-Colas. At 5:55 pm Baker was taken from his cell on death row at the Polunsky Unit in Livingston, Texas, USA, to the death chamber in Huntsville Prison, where he was executed by lethal injection—a chemical cocktail of sodium thiopental (to sedate), pancuronium bromide (to collapse the diaphragm and lungs), and potassium chloride (to stop the heart).

The prison in Huntsville has the busiest death chamber in the USA. By November 2002, 31 people had been executed there—over half of the executions in the country. Prosecuting Baker cost the state of Texas around US$2.16 million over and above the cost of a trial that does not involve the death penalty (or about three times the cost of imprisoning someone in a single cell at the highest security level for 40 years).

Death penalty trials last longer and, because sentences are almost automatically appealed, prisoners remain on death row for an average of 10 years and 7 months. Cutting the right to appeal would be a money-saving measure, but the price could be high: A 2000 Columbia University Law School study found that 68 percent of death penalty verdicts appealed between 1973 and 1995 were so seriously flawed that they had to be sent back for a new trial or resentencing.

Am 30. Mai 2002 um 16.30 Uhr begann Stanley Allison Baker jr. mit dem Verzehr von zwei 500 g schweren Ribeye-Steaks, 450 g Puter in feinen Scheiben, zwölf Scheiben gebratenem Speck, zwei Hamburgern mit Mayonnaise, Zwiebelringen und Salat, zwei dicken Ofenkartoffeln mit Butter, Sour Cream, Käse und Schnittlauch, vier Scheiben Käse, einem Chef-Salat mit Blauschimmelkäse-Dressing, zwei Maiskolben und einer Familienpackung Pfefferminzeis mit Schokosplittern. Dazu trank er vier Dosen Cola mit Vanillegeschmack. Um 17.55 Uhr wurde Stanley aus seiner Zelle im Todestrakt der Polunsky Unit in Livingston (Texas) in die Exekutionskammer im Gefängnis von Huntsville gebracht, wo er per Todesspritze hingerichtet wurde – mittels eines Chemikaliencocktails aus Natriumpenthotal (zur Beruhigung), Pancuroniumbromid (zur Lähmung der Atmungsorgane) und Potassiumchlorid (das zum Herzstillstand führt).

In der Hinrichtungszelle von Huntsville ist viel los. Dort finden die meisten Exekutionen der USA statt: Bis November 2002 wurden dort 31 Todesurteile vollstreckt, über die Hälfte des ganzen Landes. Stanleys Strafverfolgung kostete den Staat Texas schätzungsweise 2,16 Millionen US$ mehr als ein Gerichtsverfahren, bei dem nicht die Todesstrafe auf dem Spiel steht, oder dreimal so viel wie eine 40-jährige Haftstrafe in einer Einzelzelle im Hochsicherheitstrakt. Prozesse, bei denen das Todesurteil verhängt wird, dauern länger, weil beinahe automatisch Berufung eingelegt wird und der Verurteilte durchschnittlich zehn Jahre und sieben Monate in der Todeszelle sitzt. Das Recht auf Berufung abzuschaffen würde selbstverständlich die Kosten senken, doch um welchen Preis? Eine Studie der juristischen Fakultät der Columbia University aus dem Jahr 2000 hat nachgewiesen, dass 68% aller Urteile, bei denen die Todesstra-

fe verhängt wurde und die zwischen 1973 und 1995 in die Berufung gingen, so fehlerhaft waren, dass der gesamte Prozess wieder augerollt oder das Urteil neu formuliert werden musste.

Le 30 mai 2002, à 16h30, Stanley Allison Baker Jr entama un repas composé comme suit : deux entrecôtes de 500 g, 450 g d'émincé de dinde, 12 tranches de bacon, deux hamburgers avec mayonnaise, oignon et laitue, deux grosses pommes de terre au four accompagnées de beurre, de crème aigre, de fromage et de ciboulette, quatre tranches de fromage, une salade du chef avec une vinaigrette au bleu, deux épis de maïs et un petit pot de crème glacée à la menthe et aux pépites de chocolat. Le tout arrosé de quatre Coca-Colas goût vanille. À 17h55, on sortit Stanley de sa cellule,

dans le couloir de la mort de la division carcérale de Polunsky, à Livingston, Texas (États-Unis), pour le conduire dans la « chambre de la mort » de la prison de Huntsville, où il fut exécuté par injection létale – un cocktail de trois substances chimiques, le thiopental de sodium (un sédatif), le bromure de pancuronium (qui inhibe le diaphragme et les poumons) et le chlorure de potassium (qui provoque un arrêt cardiaque).

De toutes les salles d'exécution du pays, celle de la prison de Huntsville est de loin la plus active. En novembre 2002, on y avait procédé à 31 mises à mort, soit plus de la moitié de celles pratiquées sur l'ensemble du pays. Comparé à un procès n'impliquant pas la peine capitale, condamner Stanley à mort a généré pour l'État du Texas un surcoût de procédure d'environ 2,16

millions $ US (soit trois fois le coût de 40 ans d'incarcération en cellule individuelle dans un quartier de très haute sécurité). En effet, les procès des condamnés à mort durent plus longtemps et, la défense faisant presque systématiquement appel, les séjours des détenus dans les couloirs de la mort s'éternisent (leur durée moyenne est de dix ans et sept mois). Pour réduire les frais, d'aucuns seraient tentés de supprimer le droit d'appel, mais le prix à payer risque d'être plus élevé encore. En effet, une étude menée en 2000 par la faculté de droit de l'université de Columbia a révélé que 68 % des peines capitales réexaminées en appel entre 1973 et 1995 recouvraient de tels vices de procédure que les tribunaux devaient être re-convoqués, soit pour entamer un nouveau procès, soit pour revoir les verdicts.

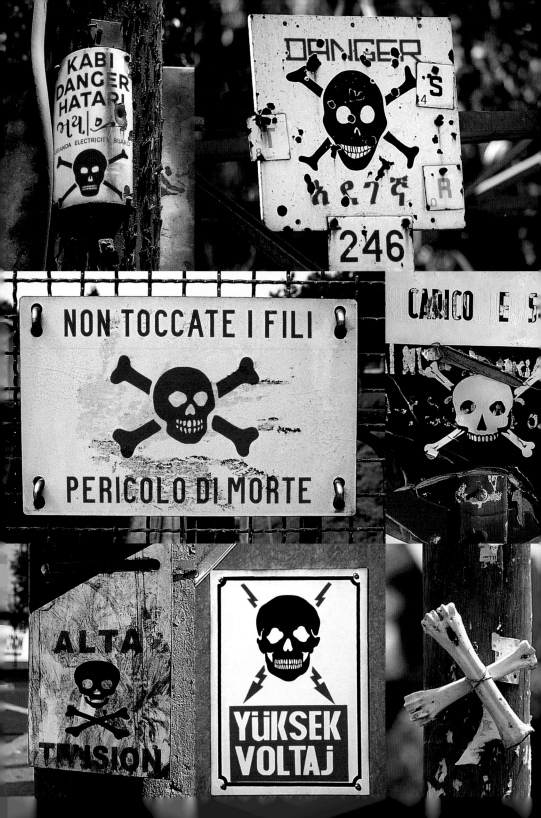

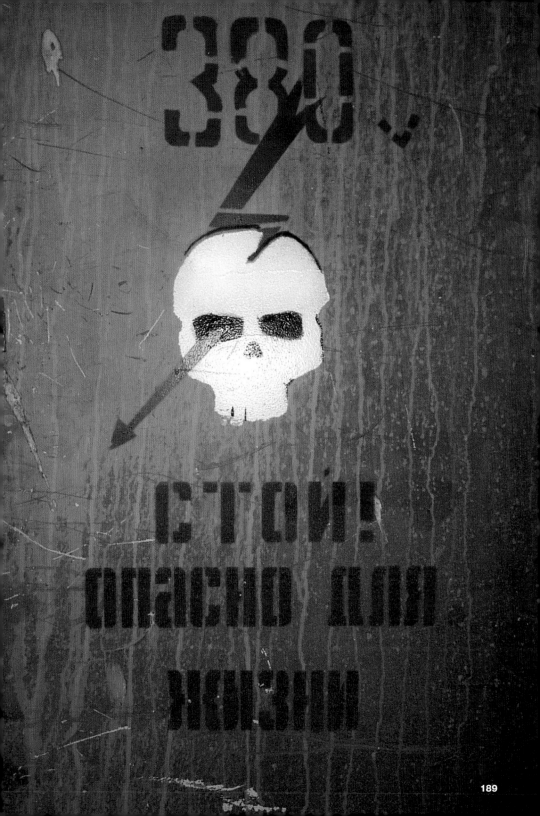

Executions
Hinrichtungen
Exécutions

Chinese executioners work the day shift. That way, prisoners can be paraded through city streets before being executed. Afterward transplant doctors can harvest the organs—all during normal working hours. Most US executioners, however, work nights. "Our executions take place at 2am, the quietest time for the prison," says Patty McQuillan of the NC Department of Corrections. "Inmates are in their cells and lights are out. If they were together they could stage a disturbance."

Chinesische Henker arbeiten tagsüber. So können die Todeskandidaten auf dem Weg zur Hinrichtung der Öffentlichkeit vorgeführt werden. Unmittelbar nach der Exekution werden den Leichen sämtliche brauchbaren Organe von Chirurgen zur Transplantation entnommen – alles zu regulären Bürozeiten. In den USA dagegen haben Henker in der Regel Nachtschicht. „Bei uns finden Hinrichtungen um zwei Uhr morgens statt, das ist im Gefängnis die ruhigste Zeit", erklärt Patty McQuillan von der Behörde für Strafvollzug in North Carolina. „Die Häftlinge sind in ihren Zellen, und das Licht ist aus. Wenn sie zusammen wären, könnte es zu Unruhen kommen."

Les bourreaux chinois opèrent pendant les heures ouvrables. Ainsi, les prisonniers peuvent être promenés et exhibés dans les rues avant l'exécution. À la suite de quoi les chirurgiens spécialistes des greffes auront tout loisir de prélever leurs organes, sans allonger pour autant leur journée de travail. En revanche, la plupart des bourreaux américains œuvrent de nuit. « Nos exécutions ont lieu à deux heures du matin, l'heure la plus calme dans les prisons, précise Patty McQuillan, du Département correctionnel de Caroline du Nord (États-Unis). Les détenus sont dans leur cellule, lumières éteintes. S'ils se trouvaient ensemble à ce moment-là, ils pourraient fomenter une émeute. »

Nevarnost
eksplozije !

Underground
Unterirdisch
Sous-sol

The Australian town of Coober Pedy is known as the "Opal Capital of the World." It's also known for low census returns, low voter turnout, high tax avoidance, gambling, and drinking. Many of its 4,000 residents—who mine 70 percent of the world's opals—live in cave dwellings to escape the year-round intense outback heat. There are underground hotels and churches too, dug out by World War I soldiers on their return from the trenches. Forty-five nationalities work in the mines, though one is missing: Australian aborigines, who though they discovered the largest seam of gems in 1946, have been frozen out of the bonanza, and are mostly found begging on the streets. They call the town *kupa piti*, or "white man's hole in the ground."

Die australische Stadt Coober Pedy ist allgemein als „Welthauptstadt des Opals" bekannt, aber auch für das geringe Interesse ihrer Einwohner an Volkzählungen und Wahlen, für Steuerhinterziehung, Glücksspiel und Alkoholkonsum. Viele der 4000 Einwohner, die 70% aller Opale der Welt schürfen, leben in unterirdischen Wohnungen, um der ganzjährigen drückenden Hitze des australischen Hinterlandes zu entkommen. Es gibt auch unterirdische Hotels und Kirchen, die von Soldaten nach ihrer Rückkehr aus den Schützengräben des Ersten Weltkriegs angelegt wurden. In den Bergwerken arbeiten Menschen, die 45 verschiedenen Nationalitäten angehören, wobei eine fehlt: Die australischen Aborigines, die 1946 die größte Opalader entdeckten, sind vom Abbau ausgeschlossen und ziehen größtenteils bettelnd durch die Straßen. Sie nennen die Stadt *kupa piti*, „Erdloch des weißen Mannes".

La ville australienne de Coober Pedy est connue comme la « capitale mondiale de l'opale ». Elle a en outre acquis un certain renom pour la vie infernale qu'elle mène aux recenseurs, pour son taux d'abstention record aux suffrages électoraux, pour ses nombreux adeptes de l'évasion fiscale et pour sa population débauchée, qui s'adonne sans retenue au jeu et à l'alcool. Parmi ses 4 000 habitants (qui extraient du sol 70 % des opales du monde), beaucoup se terrent dans des habitations troglodytes afin d'échapper à la chaleur intense qui écrase l'intérieur du territoire australien. Il existe même des églises et des hôtels souterrains, construits par des poilus de la Grande Guerre à leur retour des tranchées. Parmi les 45 nationalités qui se côtoient dans les mines, il en est une dont l'absence se remarque : les aborigènes australiens, à qui l'on doit pourtant la découverte du plus gros filon de gemmes, en 1946, ont été écartés de cette manne prolifique, et on les retrouve désormais mendiant dans les rues de la ville. Du reste, ils nomment cette dernière *kupa piti*, ce qui signifie « trou d'homme blanc dans le sol ».

Halkrisk

Gas
Gas
Gaz

When the US-owned Union Carbide pesticide plant at Bhopal exploded on December 3, 1984, 40 tonnes of methyl isocyanate (MIC), a lethal gas containing cyanide, were released into the air. Almost 2,000 people were killed immediately, and over the next few hours 8,000 more died from asphyxiation. In 1996, the International Medical Commission on Bhopal estimated that 50,000 survivors were still suffering partial or total disability. But more recent, unofficial estimates of long-term effects—such as birth defects in survivors' children and contamination of soil and ground water—put the toll at 120,000. The victims are still fighting to obtain fair compensation.

Als am 3. Dezember 1984 in einer Pestizidfabrik im indischen Bhopal, die dem US-Unternehmen Union Carbide gehörte, ein Tank explodierte, entwichen etwa 40 t Methylisocyanat (MIC), ein tödliches Gas, das Zyanid enthält. Fast 2000 Menschen waren auf der Stelle tot, in den Stunden danach erstickten 8000 weitere. Die für Bhopal zuständige internationale Ärztekommission schätzte 1996, dass 50 000 Überlebende der Katastrophe noch immer unter mehr oder weniger schweren Behinderungen litten. Nach neueren inoffiziellen Einschätzungen der Langzeitschäden (wie Geburtsschäden bei Kindern der Überlebenden und die Verseuchung von Boden und Grundwasser) liegt die Gesamtzahl der Opfer jedoch bei 120 000. Die Betroffenen kämpfen bis heute um eine angemessene Entschädigung.

Lorsque l'usine implantée à Bhopal (Inde) par le fabricant de pesticides américain Union Carbide explosa, le 3 décembre 1984, 40 tonnes d'isocyanate de méthyle (ICM), un gaz mortel contenant du cyanure, furent libérées dans l'atmosphère. Près de 2 000 personnes furent tuées sur le coup, 8 000 autres moururent asphyxiées dans les heures qui suivirent. En 1996, la commission médicale internationale chargée d'examiner l'affaire Bhopal avançait le chiffre de 50 000 survivants souffrant encore de handicaps totaux ou partiels. Cependant, des estimations officieuses plus récentes concernant les effets à long terme de la catastrophe – telles les tares de naissance chez les enfants des survivants, la contamination du sol ou celle des nappes phréatiques – situent à 120 000 le nombre réel de victimes. Au reste, reconnues ou non, celles-ci n'ont pas encore obtenu réparation.

Hot metal
Heißes eisen
Métal brûlant

If fire breaks out in your car—and you're in it—get out as quickly as possible: A burning vehicle can reach over 800 degrees Celsius. Some parts of the car, like the bumper and magnesium wheels, can explode. As can the fuel tank (but with improved safety regulations, this is now quite rare). In the US, 550 people are killed in burning vehicles every year. So don't let your car become a death trap and get it serviced regularly. If you smell gas while driving, pull over immediately. If you live in the UK, don't be surprised to find your car in flames between 10 and 10.59pm on a Saturday or a Sunday. That's when most malicious car fires—causing 20 deaths a year—are started.

Sollte in deinem Auto Feuer ausbrechen, während du darin sitzt, steig so schnell wie möglich aus: Ein brennendes Fahrzeug erhitzt sich sekundenschnell auf über 800°C. Verschiedene Teile des Autos wie zum Beispiel Stoßstangen und Magnesiumräder können leicht explodieren. Dasselbe gilt für den Benzintank (obwohl dies dank verbesserter Sicherheitsvorkehrungen relativ selten geschieht). In den USA kommen jährlich 550 Menschen bei Fahrzeugbränden ums Leben. Lass also dein Auto nicht zur tödlichen Falle werden und bring es regelmäßig in die Werkstatt. Wenn du während der Fahrt Benzin riechst, halte sofort an – und steck dir bitte keine Zigarette an. Wer in Großbritannien lebt, sollte sich nicht wundern, wenn sein Auto am Samstag- oder Sonntagabend zwischen 22.00 Uhr und 22.59 Uhr Feuer fängt. Zu dieser Stunde finden die meisten Brandanschläge auf Autos statt, bei denen jährlich 20 Menschen zu Tode kommen.

Si votre voiture prend feu, ne vous y éternisez pas. La température pourrait grimper à plus de 800°C. Certaines pièces, tel le pare-choc ou les roues, contiennent du magnésium et risquent d'exploser, de même que le réservoir (quoique beaucoup plus difficilement, grâce aux nouvelles normes de sécurité). Aux États-Unis, 550 personnes meurent chaque année dans des véhicules en flammes. Aussi, ne laissez pas votre voiture devenir un piège de mort, et faites-la réviser régulièrement. Si vous percevez une odeur d'essence pendant que vous conduisez, arrêtez-vous – mais, de grâce, n'allumez pas une cigarette. Et si vous résidez au Royaume-Uni, ne soyez pas surpris si votre voiture s'enflamme entre 22 heures et 22h59, un samedi ou dimanche soir : c'est l'heure de prédilection des incendiaires – dont les ardeurs pyrotechniques causent, précisons-le, 20 morts par an.

RECUERDA

NO HAGAS
FUEGO

Landslide
Erdrutsch
Éboulement

Nepal—a country that is 83 percent mountains—has more landslides than anywhere else in the world. An average of 200 people are killed every year and around US$1 billion worth of damage is caused. If you're in a mountainous area, look out for tilted trees and small landslides—they could be a presage of a larger one. Be especially alert during heavy rains (or light rains after heavy rains) and listen for unusual noises like trees breaking or rocks moving. And if you are caught in a landslide, either run to stable ground or lie down and curl up into a ball.

Nepal besteht zu 83% aus Bergen und verzeichnet die meisten Erdrutsche der Welt. Die Schlammlawinen fordern im Jahr 200 Opfer und verursachen Schäden im Wert von einer Milliarde US$. Wenn du in einer hügeligen Gegend unterwegs bist, halt nach schräg stehenden Bäumen und kleineren Erdrutschen Ausschau, die oft Vorboten größerer Lawinen sind. Vorsicht ist vor allem bei starken Regenfällen (oder leichtem Regen unmittelbar nach einem Wolkenbruch) geboten. Achte auf ungewöhnliche Geräusche wie splitterndes Holz oder rollende Steine. Solltest du dich dennoch auf rutschender Erde befinden, versuch entweder festen Boden unter die Füße zu bekommen oder leg dich hin und roll dich ein.

Montagneux sur 83% de son territoire, le Népal est le pays du monde où les glissements de terrain sont les plus fréquents. Ils tuent chaque année 200 personnes en moyenne et causent près de un milliard $ US de dégâts. Si vous vous trouvez en montagne, prenez garde aux arbres penchés ou aux éboulements mineurs, qui peuvent présager d'un glissement plus important. Cependant, soyez particulièrement vigilants lors de fortes averses (ou des pluies modérées qui les suivent parfois) et attentifs aux bruits inhabituels, qu'il s'agisse de troncs d'arbres qui se rompent ou pierres qui roulent. Et si, malgré tout, vous êtes pris dans un éboulement, deux solutions : courez vous réfugier sur un sol stable ou roulez-vous en boule et attendez.

**Falling
Ice**

**Do Not Go
Beyond This
← Point →**

PERICOLO DI CROLLO

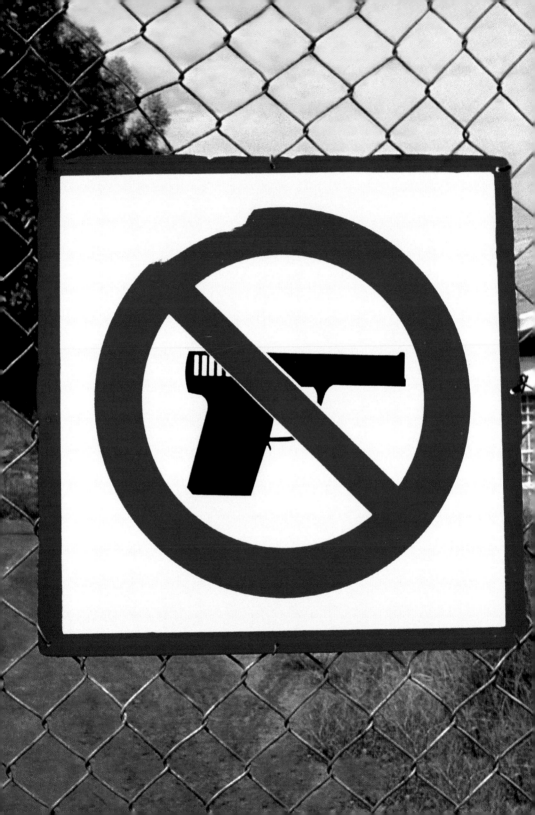

215
Weapons
Waffen
Armes

Firecrackers
Knaller
Pétards

For at least 2,000 years, people in China have been setting off firecrackers filled with gunpowder (invented by the Chinese) to celebrate New Year. But light a firecracker in Beijing nowadays and you could be heading for a fine. The city has banned all firecrackers since 1993 for safety reasons—they cause fires and injury (other large cities also have total or partial bans). But the ban hasn't quite solved the problem yet. During Beijing's four-day 2003 New Year celebrations, 260 people were treated in hospital for firework-related injuries. The reason, authorities say, is that people buy illegal fireworks, which are more dangerous as they often contain more gunpowder, as well as banned chemicals. Fireworks are usually set off as part of a celebration, but during the 2003 SARS virus outbreak, peasants in Shanxi province found another use: They lit firecrackers to ward off the disease.

Seit mindestens 2000 Jahren wird in China der Einzug des neuen Jahres mit Feuerwerkskörpern, die mit Schießpulver (eine chinesische Erfindung) gefüllt sind, gefei-

ert. Aber wer heute in Peking einen Knallkörper loslässt, muss mit einer saftigen Geldstrafe rechnen. Seit 1993 sind in der Stadt Feuerwerkskörper aus Sicherheitsgründen verboten, da sie oft Brände und Verletzungen verursachen (auch in anderen großen Städten sind sie entweder völlig oder wenigstens teilweise untersagt). Das Problem wurde durch die Sperre allerdings nicht gelöst: Während der viertägigen Neujahrsfestivitäten 2003 wurden 260 Personen mit Brandverletzungen in die städtischen Krankenhäuser eingeliefert. Den Behörden zufolge werden oft illegale Feuerwerkskörper gekauft, die gefährlich sind, weil sie größere Mengen Schießpulver sowie verbotene Chemikalien enthalten. Knaller sind in China normalerweise fester Bestandteil einer Feier. Im Jahr 2003, während der Epidemie der Lungenkrankheit SARS, wurden die Böller von den Bauern der Provinz Shanxi zweckentfremdet: Man knallte, um die Krankheit zu vertreiben.

Voilà 2 000 ans pour le moins que les Chinois font sauter des pétards remplis de poudre (dont ils sont du

reste les inventeurs) pour célébrer le nouvel an. Et pourtant, depuis peu, on risque une amende à Pékin si l'on s'amuse à ce petit jeu. C'est en 1993 que la municipalité a résolu d'interdire les pétards, pour des raisons de sécurité, car ils provoquaient blessures diverses et incendies (d'autres villes ont pris des mesures similaires, prononçant des interdictions totales ou partielles). Cela dit, ces mesures autoritaires n'ont pas totalement résolu le problème : durant les quatre jours que durèrent les fêtes du nouvel an 2003 à Pékin, 260 personnes durent être hospitalisées pour blessures liées à l'explosion de pétards. Aux dires des autorités, les responsables seraient non les pétards, mais les feux d'artifice privés, totalement illégaux et beaucoup plus dangereux car ils contiennent souvent plus de poudre, additionnée, pour tout arranger, de produits chimiques prohibés. Si, en Chine, les feux d'artifice couronnent d'ordinaire une célébration, les paysans de la province du Shanxi leur ont trouvé un autre usage : lorsque l'épidémie de SRAS frappa, en 2003, ils en allumèrent pour éloigner le virus.

Land mines
Landminen
Mines antipersonnel

Aki Ra lives near Siem Reap, Cambodia, and started laying land mines for the Khmer Rouge and Vietnamese army aged five. "My whole life is war and mines. I laid so many before, when I was small. I didn't understand, I just did it for the army." Now Aki Ra spends his days clearing mines instead. "I have many friends now, because I do good." Aki Ra claims it will take at least another 20 years to make his country safe—but only, he warns, if reports that mines are still being laid near the Thailand-Cambodia border aren't true. Does he pray? "Not very often," he says, though some of his friends do. "They even have tattoos for protection, but they still die. Praying doesn't clear the mines. Only work can do that."

Aki Ra lebt in der Nähe von Siem Reap in Kambodscha. Mit fünf Jahren begann er, für die Roten Khmer und die vietnamesische Armee Landminen zu legen.

„Mein ganzes Leben bestand aus Krieg und Minen. Ich habe Unmengen Minen gelegt, als ich noch klein war. Da verstand ich das alles nicht. Ich tat es einfach für die Armee." Jetzt spürt er die Minen wieder auf und entschärft sie. „Heute habe ich viele Freunde, weil ich Gutes tue." Aki Ra meint, es werde noch mindestens 20 Jahre dauern, bis sein Land sicher sei, und auch dies nur dann, wenn die Berichte über neue Minenfelder an der Grenze zwischen Thailand und Kambodscha nicht der Wahrheit entsprächen. Betet er? „Nicht besonders häufig", erklärt Aki Ra, auch wenn viele seiner Freunde es täten. „Manche haben sogar Tätowierungen, die sie davor schützen sollen, auf eine Mine zu treten, aber sie sterben trotzdem. Mit Gebeten wird man die Minen nicht los, nur mit harter Arbeit."

Aki Ra réside non loin de Siem Reap (Cambodge). À l'âge de cinq ans, cet homme posait déjà des mines pour le compte des Khmers rouges et de l'armée vietnamienne. «Toute ma vie, je n'ai connu que la guerre et les mines. J'en ai posées tellement, quand j'étais petit! Je ne comprenais pas. Je faisais ça pour l'armée.» À présent, il se consacre à leur élimination. «Maintenant que je fais le bien, j'ai beaucoup d'amis.» À son avis, il faudra au bas mot 20 ans pour que le sol de son pays soit de nouveau sans danger – à condition que les rumeurs qui courent soient infondées, précise-t-il, car, selon des rapports récents, on serait en train de miner à nouveau la frontière entre le Cambodge et la Thaïlande. Pratique-t-il la prière? «Pas souvent», nous dit-il. Au contraire de certains de ses amis. «Ils se font même faire des tatouages protecteurs. Mais ça ne les empêche pas de mourir. Ce ne sont pas les prières qui désamorcent les mines, c'est l'huile de coude.»

DANGER - MINES

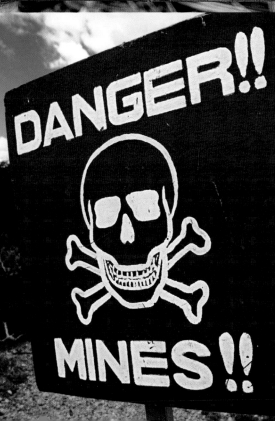

DANGER!!

MINES!!

ROTECTED PLACE 保护区

NO ADMITTANCE UNAUTHORISED PERSONS

闲人
免进

LARANG MASOK JIKA TIADA KEBENARAN

உத்தரவின்
உள்ளே
பிரவேசிக்
கூடாது

EMPAT LARANGAN பாதுகாப்பு உள்ள இட

RESPASSERS WILL BE PROSECUTED.

ALLARME AUTOMATICO
L'EQUIPAGGIO NON PUO'
APRIRE IL VANO VALORI

Gun control
Waffenkontrolle
Port d'arme réglementé

It costs only six baht (US$0.14) to buy a gun license in Thailand. No shooting experience is required, and saying you want to protect yourself is enough to get you a gun. Since there are 3.5 million legal and illegal guns in the country, the Thai government has now established "gun-free zones" in discos and tourist areas, to calm the fears of foreign visitors. "I cut a deal with the Thai Army," says Akira Shimura, a retired Japanese soldier, whose shooting gallery is the only one still allowed to operate in Bangkok. It's open only to those supposedly gun-shy foreigners, and business is booming.

Für nur 6 Baht (0,14 US$) bekommst du in Thailand einen Waffenschein. Schießerfahrungen sind nicht erforderlich, man braucht nur zu erklären, man benötige die Waffe zum Selbstschutz. Da in Thailand rund 3,5 Millionen legale und illegale Waffen im Umlauf sind, hat die Regierung Diskotheken und Touristengebiete eigens zu „schusswaffenfreien Zonen" erklärt, um besorgte Ausländer zu beschwichtigen. „Ich habe mich mit der thailändischen Armee geeinigt", erklärt Akira Shimura, ein japanischer Veteran, dessen Schießhalle als einzige im Zentrum Bangkoks noch zugelassen ist. Zutritt haben nur die angeblich so waffenscheuen Ausländer, und das Geschäft läuft bestens.

Pour obtenir un permis de port d'arme en Thaïlande, il suffit de débourser 6 BAHT (0,14 $ US). Aucune pratique n'est exigée : il suffit d'alléguer que vous souhaitez vous protéger. Inquiet cependant des 3,5 millions d'armes à feu, licites ou non, qui circulent dans le pays, le gouvernement vient d'instaurer des « zones sans armes » dans les discothèques et les sites touristiques, afin de rassurer les visiteurs étrangers. « J'ai conclu un marché avec l'armée thaïlandaise », confie Akira Shimura, militaire japonais à la retraite et propriétaire du dernier champ de tir encore autorisé dans le centre-ville de Bangkok. Précisons que seuls les étrangers y sont admis – ceux-là même que les coups de feu étaient censés effaroucher – et que les affaires sont florissantes.

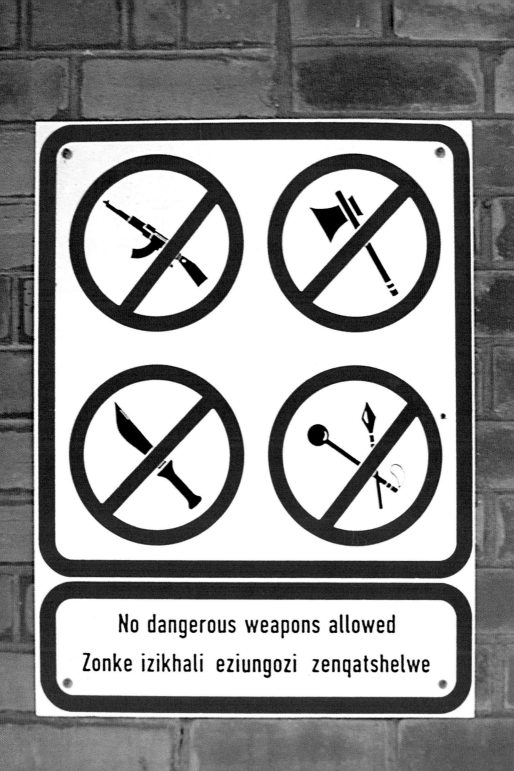

No dangerous weapons allowed

Zonke izikhali eziungozi zenqatshelwe

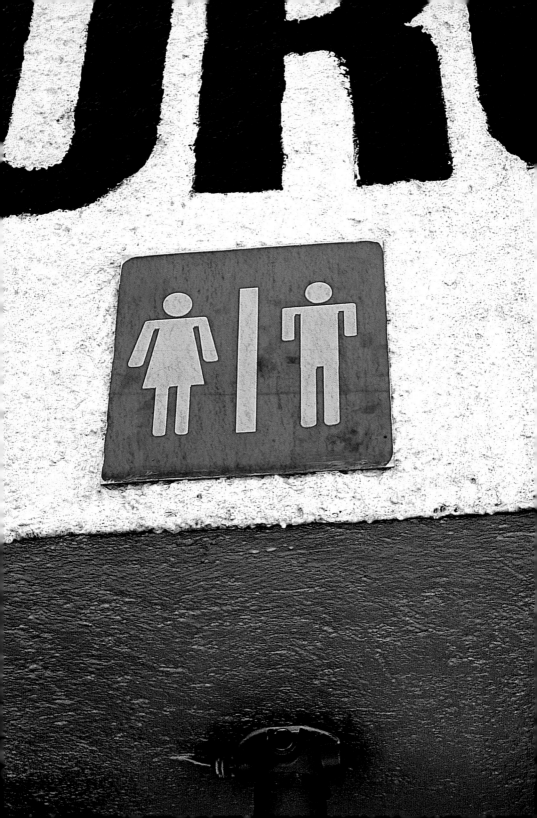

231
Toilets
Toiletten
Toilettes

Untouchable
Unberührbare
Intouchables

Out of 1 billion people living in India, 700 million have no decent toilet. Men defecate wherever and whenever; women are forced, out of modesty, into dark fields before dawn and after sunset. In hygiene terms, India is a massive, open-air latrine, with health consequences to match (a child dies every eight seconds from sanitation-related diseases). To clean it up, there are the scavengers, people from India's lowest castes (Bhangi or Dalit), known more commonly as "untouchables." They probably originated from prisoners of war centuries ago, at the time of the Muslim invasions. Enlisted to clean up after *purdah* women who couldn't leave their quarters, untouchables emptied "night-soil" with their bare hands, and have yet to recover from the stigma. Hence their polluted status and a job that was never likely to be surplus to requirements. India has 135 million kg of excrement to dispose of every day, and over 600,000 people still make a living from night-soil removal.

Von einer Milliarde Indern haben 700 Millionen keinen Zugang zu sanitären Anlagen. Männer erledigen ihr großes Geschäft, wo und wann immer sie müssen, Frauen setzen sich aus Scham vor Sonnenaufgang und am späten Abend in dunkle Ecken und auf die Felder. Was die hygienischen Bedingungen angeht, ist Indien eine einzige riesige Freiluftlatrine – mit unsäglichen gesundheitlichen Folgen (alle acht Sekunden stirbt ein Kind an einer Krankheit, die mit mangelnder Hygiene zu tun hat). Den Dreck zu beseitigen ist die Aufgabe der Müllsammler, in der Regel Angehörige der niedrigsten Kasten in Indien, der Bhangi oder Dalit, die besser als „Unberührbare" bekannt sind. Diese Kategorie geht wahrscheinlich auf die Kriegsgefangenen zurück, die vor Jahrhunderten während der muslimischen Eroberungszüge dazu abkommandiert wurden, hinter den Haremsdamen „aufzuräumen", die ihre Gemächer nicht verlassen durften. Dazu gehörte auch, mit bloßen Händen ihren „nächtlichen Schmutz" zu entsorgen. Dieses Stigma hängt den Unberührbaren Jahrhunderte später noch an, ist der Grund für ihren Ausschluss aus der Gesellschaft und ihre undankbare Arbeit, die kaum jemals mehr als das Nötigste brachte: Tag für Tag sind in Indien 135 Millionen kg Exkremente zu beseitigen. Über 600 000 Menschen verdienen ihren Lebensunterhalt noch heute mit dem Wegschaffen nächtlichen Schmutzes.

Sur le milliard d'habitants que compte l'Inde, 700 millions ne disposent pas de toilettes dignes de ce nom. Les hommes défèquent n'importe où et n'importe quand, tandis que la pudeur oblige ces dames à filer à travers champs, dans l'obscurité du petit matin ou du crépuscule. En termes d'hygiène, le sous-continent indien est donc un gigantesque W.-C. à ciel ouvert, avec les retombées sanitaires que l'on imagine (un enfant meurt toutes les huit secondes d'une maladie directement liée au manque d'hygiène). Pour nettoyer ces toilettes géantes, la société indienne a ses volontaires désignés d'office, ses éboueurs de naissance. Il s'agit des membres des castes inférieures (*bhangi* et *dalit*), communément nommés les «intouchables» et descendants probables des prisonniers de guerre faits à l'époque des invasions musulmanes. Recrutés alors pour nettoyer les appartements des femmes cloîtrées au sérail, ils devaient vider leurs pots de chambre à la main. Aux yeux des autres castes, la souillure demeure et leurs doigts sont impurs à jamais. D'où leur statut d'individus «pollués» et l'emploi qu'on leur assigne – emploi pour lequel, au demeurant, l'offre ne risque jamais d'excéder la demande: l'Inde produit en effet (et doit par conséquent gérer) 135 millions de kilos d'excréments par jour. Plus de 600 000 personnes gagnent encore leur vie en ramassant les déjections nocturnes.

Shit
Scheiße
Merde

Defecation—a right or a privilege? Countries around the world are still working on a consistent policy for public toilets. In Vietnam, it can take hours to find one as there are no signs to indicate their presence. In China's big cities, locals may pay 0.3 yuan (US$0.03) or so per toilet visit; foreigners are charged double. In rural China you'll be squatting over a trough, with no doors, but it's free, although one resident reports that latrines are usually so dirty, people prefer to defecate in garbage dumps. For cheaper toilet options, move to British Columbia, Canada, where the Public Toilet Act makes it illegal to charge, or become a student in Jakarta, Indonesia, where you'll get a 60 percent discount. If you're caught short in Singapore, though, keep your wallet handy. Not flushing is an offense, and undercover health officials lurk in rest rooms to issue on-the-spot fines of S$29 (US$17); repeat offenders can be charged S$925 ($558).

Ausscheidung – Recht oder Privileg? Weltweit wird in allen Ländern an einer kohärenten Gesetzgebung für öffentliche Toiletten gearbeitet. In Vietnam kann es Stunden dauern, bis man eine Toilette findet (es gibt keine Hinweisschilder). In Chinas Großstädten zahlen Anwohner etwa 0,3 Yuan (0,03 US$) pro Toilettengang – Ausländer berappen das Doppelte. Auf dem Lande wird sich der Bedürftige in China auf den Donnerbalken hocken müssen, ohne Türen, aber dafür umsonst. (Die Latrinen sind allerdings normalerweise so schmutzig, dass die meisten lieber auf Müllhalden gehen, berichtet ein Anwohner.) Kostengünstig kann man seine Bedürfnisse in British Columbia (Kanada) erledigen, wo die Verordnung für öffentliche Toiletten es verbietet, dafür Geld zu kassieren. Als Student in Jakarta (Indonesien) bekommt man eine Ermäßigung von 60%. Sollte man es in Singapur eilig haben, empfiehlt es sich, das Portemonnaie griffbereit zu haben: Nicht zu spülen ist dort ein Vergehen, und Polizisten in Zivil lauern oft in den Toilettenanlagen, um an Ort und Stelle Geldstrafen von 29 Singapur $ (17 US$) zu kassieren. Wiederholungstäter zahlen bis zu 925 Singapur $ (558 US$).

Déféquer – droit ou privilège? Aux quatre coins du monde, les États travaillent encore à se doter d'une politique cohérente en matière de toilettes publiques. Au Viêt Nam, on peut mettre des heures à en dénicher, aucun panneau n'indiquant leur présence. Dans les grandes agglomérations chinoises, on demande parfois quelque 0,3 Y (0,03 $ US) aux habitants pour une visite au petit coin… et le double aux étrangers. En Chine rurale, on se montre plus humain : il faudra certes vous accroupir au-dessus d'un trou, dans une cabine sans porte, mais cela ne vous coûtera pas un sou (cependant, les latrines sont généralement si sales que les gens préfèrent déféquer dans les décharges publiques, rapporte un habitant). Pour de vraies économies, émigrez en Colombie-Britannique (Canada), où la loi régissant les toilettes publiques prohibe toute tarification. Ou prenez le statut d'étudiant à Jakarta (Indonésie) : il vous ouvrira droit à une remise de 60 %. Pris d'une urgence naturelle à Singapour? Gardez votre portefeuille à portée de main. En effet, oublier de tirer la chasse est une infraction, et des fonctionnaires de l'Inspection sanitaire rôdent incognito dans les toilettes publiques, espérant bien vous prendre en flagrant délit et vous assener une amende de 29 $ SI (17 $ US). Tarif progressif pour les récidivistes (jusqu'à 925 $ SI, soit 558 $ US).

...च वाक्या:

पशु-पक्षां सारखी
घाण करु नका.
माणसा सारखे
जबाबदारीने वागा
आपला परिसर स्वच्छ
ठेवणे जरुरीचे आहे.

बृहन्मुंबई महानगरपालि
कचरा डब्यातच टा
अन्यथा दंड / कैद हो
तक्रार . ४९३५६८७ ☎

Bleach
Chlor
Eau de javel

Donatella Pelliccioli cleans toilets at a highway service station in northern Italy. She sees about 3,000 people pass through her rest rooms every day. "No one works here overnight, so when I get here in the morning, the toilets are very dirty and smelly. First, I clean everything with very strong bleach; otherwise the stink would never go away. The worst is Sunday morning, when hundreds of people use these toilets, going and coming from discos around here. There's shit all over the place, and a lot of vomit, too—in the urinals, on the floor, in the sinks. More than once a week we find shit on the floor. We hear all the noises too; we can't avoid it. I'm used to it now, but when I started this job I thought I'd never make it. Sometimes, people understand what kind of work we do, and they compliment us because we keep everything so clean. I like it when that happens. All jobs have their defects, but for this one you need a strong stomach."

Donatella Pelliccioli ist Klofrau in den Toiletten einer Autobahnrast-stätte in Norditalien. Jeden Tag be-nutzen etwa 3000 Menschen ihre Örtlichkeiten. „Nachts arbeitet hier niemand. Wenn ich morgens an-komme, sind alle Toiletten furcht-bar dreckig und stinken wie die Pest. Zuerst wische ich überall mit Chlor, sonst würde der Gestank nie weggehen. Am schlimmsten ist es am Sonntagmorgen, wenn sie zu Hunderten hier aufs Klo gehen, meistens direkt aus den Diskos in der Umgebung. Da ist dann alles voller Scheiße und Erbrochenem – sämtliche Pissoirs, die Wasch-becken, der Fußboden. Mehr als einmal in der Woche ist der Boden mit Scheiße verschmutzt. Man kriegt auch alle möglichen Geräu-sche mit, ist ja nicht zu vermeiden. Jetzt habe ich mich daran ge-wöhnt, aber als ich mit diesem Job anfing, dachte ich, ich würde das nie aushalten. Es gibt Leute, die schätzen unsere Arbeit und loben uns für die Sauberkeit hier. Das hö-re ich gern. Jeder Job hat Nachtei-le, aber für den hier braucht man wirklich ein dickes Fell."

Madame Pipi de son métier, Do-natella Pelliccioli entretient les toilettes d'une station-service, sur une autoroute d'Italie du Nord. Elle y voit défiler près de 3000 usagers par jour. «Ici, il n'y a per-sonne qui travaille la nuit alors, quand j'arrive le matin, les toi-lettes sont toutes dégoûtantes et ça pue. Je commence par tout nettoyer à la javel très forte, sinon l'odeur ne partirait pas. Le pire, c'est le dimanche matin – il y a des centaines de gens qui s'arrêtent dans ces toilettes, en route pour les boîtes du coin ou bien au re-tour, et ils laissent de la merde partout, plein de vomi aussi, dans les urinoirs, sur le carrelage, dans les lavabos. Même en semaine, on trouve plus d'une fois du caca par terre. On entend les bruits aussi – ça, on ne peut pas l'éviter. Maintenant, je suis habituée, mais quand j'ai commencé ce boulot, j'ai cru que je n'y arriverais jamais. Il y a quelquefois des gens qui comprennent ce que c'est, et qui nous font des compliments parce que tout est bien propre. Quand ça arrive, ça me fait bien plaisir. Tous les métiers ont leurs défauts, mais pour celui-ci, il faut avoir l'es-tomac bien accroché. »

femmes

Lifesaver
Lebensretter
Mon sauveur !

In 1997, readers of UK-based *Focus* magazine voted the toilet the single greatest invention in history, over fire, the wheel and steam power. The lavatory, declared Harvard geneticist Gary Ruvkun, has been "the biggest variable in extending lifespan." In the developing, toilet-poor world, he pointed out, lifespans are up to 30 years less than in WC-equipped countries. And since the water closet was popularized in the nineteenth century, lifespans in the industrialized world have risen by 45 years. "The Greeks lost the Peloponnesian War because they had no toilets," says Mulkh Raj, of The Sulabh International Museum of Toilets near Delhi, India. "They got cholera and never recovered." Just as the mighty Persians, fighting the Persian Wars eight centuries earlier, fell to a plague born from their own undisposed-of excreta. In the Vietnam War, *pungi* sticks—sharpened bamboo spikes coated with excrement and planted in the ground to pierce feet—supposedly caused half of all US casualties.

Die Leser der britischen Zeitschrift *Focus* kürten 1997 bei einer Umfrage die Toilette zur wichtigsten Erfindung aller Zeiten, noch vor dem Feuer, dem Rad und der Dampfmaschine. „Das Wasserklosett", erklärt Gary Ruvkun, Genetiker der Universität Harvard, „ist der wichtigste Faktor beim Anstieg der Lebenserwartung." In der Dritten Welt, wo es nur vereinzelt Toiletten gibt, sei die Lebenserwartung bis zu 30 Jahre niedriger als in Ländern mit WC. Seit das Wasserklosett im 19. Jahrhundert populär wurde, hat sich die durchschnittliche Lebenserwartung in den Industrieländern um 45 Jahre erhöht. „Die Griechen verloren den Peloponnesischen Krieg, weil sie keine anständigen Klos hatten", meint Mulkh Raj, Leiter des Internationalen Toilettenmuseums Sulabh bei Delhi (Indien). „Bei ihnen brach die Cholera aus, davon haben sie sich nie wieder richtig erholt." Dasselbe gilt für die mächtigen Perser: Acht Jahrhunderte zuvor fielen sie während der Perserkriege einer Epidemie zum Opfer, die von ihren eigenen unentsorgten Exkrementen verursacht war. Im Vietnamkrieg waren angeblich die Hälfte aller Todesfälle unter US-Soldaten auf *Pungi*-Stäbchen zurückzuführen – angespitzte Bambussplitter, die mit Kot beschmiert und in den Boden gesteckt wurden, damit der Feind hineinlief und sich die Füße zerstach.

En 1997, les lecteurs du magazine *Focus*, basé au Royaume-Uni, furent invités à désigner la plus grande invention de tous les temps. Ils élirent les toilettes, qui, contre toute attente, devancèrent le feu, la roue et la machine à vapeur. Et pour cause : les W.-C., a déclaré le généticien de Harvard Gary Ruvkun, ont été et restent « la variable la plus apte à allonger l'espérance de vie ». Dans les pays en voie de développement, pauvres en toilettes, la durée de vie moyenne est jusqu'à 30 fois inférieure à celle qui prévaut dans les pays équipés. Inversement, depuis que les cabinets se sont popularisés dans les pays industrialisés, au XIXe siècle, l'espérance de vie s'est allongée de 45 ans. « Si les Grecs ont perdu la guerre du Péloponnèse, c'est parce qu'ils n'avaient pas de toilettes, souligne Mulkh Raj, conservateur du musée des Toilettes que l'association Sulabh International a ouvert à proximité de Delhi (Inde). Le choléra les a décimés et affaiblis. » Un handicap qu'avaient déjà connu les Perses huit siècles plus tôt, durant les guerres persiques, lorsque, malgré leur puissance, ils avaient succombé à une épidémie de peste née de leur propres déjections qui s'amoncelaient. Pendant la guerre du Viêt Nam, ce sont, dit-on, des bâtons *pungi* – piques de bambou aiguisées dont on enduisait la pointe d'excréments et qu'on plantait dans la terre pour perforer les pieds de l'ennemi – qui causèrent la moitié des pertes humaines dans le camp américain.

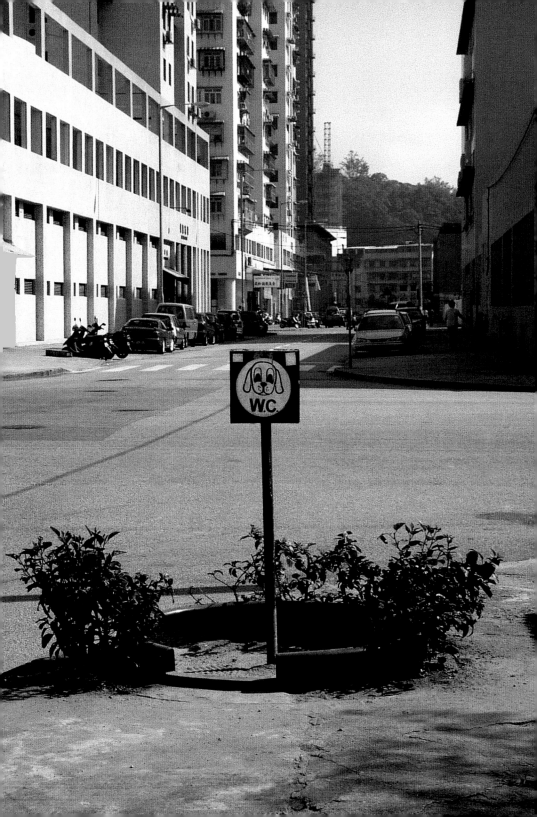

SANITÃ
2÷ Pesos
DAMAS

DAMAS

Diapers
Windeln
Couches-culottes

Toilet training is a child's major conflict. On one hand, parents sick of changing diapers want their children to use a toilet as soon as possible. On the other, toddlers object to being told when to let loose. Saying no, say psychologists, is probably the first chance toddlers have to assert their individuality. Frustrated parents should think twice before getting mad, though. A child's nervous system is not developed enough to control the sphincter until the age of about two anyway, and according to Freudian psychoanalysts, toilet training carries lifelong consequences if not done correctly. Children punished for soiling their diapers can become afraid to throw things away or make decisions. And parents can scar their children without saying a word: Babies consider their first bowel movement in the potty as a gift to mom or dad and are wounded when parents immediately dispose of it.

Kinder, die lernen sollen, aufs Töpfchen zu gehen, stehen vor dem ersten großen Konflikt ihres Lebens. Einerseits haben die Eltern die Nase voll vom Windeln wechseln und wollen, dass das Kind so schnell wie möglich sauber wird. Andererseits haben kleine Kinder eine ausgesprochene Abneigung dagegen, auf Kommando zu produzieren. Das Töpfchen zu verweigern ist für sie wahrscheinlich die erste Gelegenheit, ihre Individualität zu bezeugen, wie Psychologen meinen. Frustrierte Eltern sollten sich Folgendes vor Augen halten, bevor ihnen der Kragen platzt: Das Nervensystem eines Kleinkindes ist ohnehin bis zum Alter von etwa zwei Jahren von der Entwicklung her nicht in der Lage, den Schließmuskel zu kontrollieren. Und nach der Freud'schen Lehre kann falsches Toilettentraining lebenslange Konsequenzen haben: Kinder, die dafür bestraft werden, dass sie in die Windeln machen, könnten Hemmungen entwickeln, Dinge wegzuwerfen oder Entscheidungen zu treffen. Außerdem können Eltern ihre Kinder selbst dann verletzen, wenn sie kein Wort sagen: Kleinkinder betrachten ihre ersten Häufchen-im-Töpfchen als Geschenk an Mama und Papa und vertragen es gar nicht gut, wenn man sie gleich entsorgt.

L'apprentissage de la propreté est l'une des premières crises majeures que traverse le jeune enfant. D'un côté, les parents las de changer les couches tiennent à ce que leur rejeton utilise les toilettes le plus prestement possible. De l'autre, bébé ne voit pas pourquoi il ferait seulement quand on le lui dit. Selon les psychologues, le refus du pot est probablement la première occasion dont peuvent se saisir les tout-petits pour affirmer leur individualité. Cependant, parents contrariés, réfléchissez bien avant de vous fâcher tout rouge. Quoi que vous tentiez, le système nerveux d'un enfant n'est pas suffisamment développé pour lui permettre de maîtriser ses sphincters avant l'âge de deux ans environ. De surcroît – renchérit l'école freudienne –, un apprentissage de la propreté mené à tort et à travers risque de traumatiser un individu à vie. Les punitions reçues parce que l'enfant a souillé sa couche peuvent par exemple induire chez lui la phobie de jeter ou celle de prendre des décisions. Ajoutons que les parents marquent parfois leurs enfants pour la vie sans même prononcer un mot. En effet, les bébés considèrent leur premier caca-popo comme un cadeau à papa ou maman. Imaginez le traumatisme s'ils les voient jeter l'offrande sitôt faite !

Loitering
Herumlungern
Rôdeurs

"**Gays** are the main problem here, a big problem. I don't have anything against gays, but there are some coming down here, hanging around the toilet, picking up people and sometimes you find two gays in a cubicle, I don't like that. I kick them out. By rights, two are not supposed to be in a cubicle. If you pick up somebody, get out of my toilet and go somewhere else. If I look down at the cubicle and I see four legs underneath I just say, 'You two get out right now, I'll call the police.' There are the same people coming here all the time. You've got white chaps, Asian chaps, black chaps. That's why I have to watch the toilet all the time, every single day, from 7.30am until 6pm in the evening." This bathroom attendant has been working at the public toilet in Stephenson Place, Birmingham, UK, since 1986. His name, however, remains a mystery.

„**Schwule** sind hier das Hauptproblem, wirklich schlimm. Persönlich habe ich nichts gegen Schwule, aber es gibt welche, die kommen hier runter, hängen vor den Toiletten rum, quatschen Leute an, und manchmal finde ich zwei in einer Kabine. Das will ich nicht, die schmeiße ich raus. In den Kabinen ist Platz für eine Person, mehr nicht. Wenn du schon jemanden abschleppen musst, geh woanders hin und bleib gefälligst aus meiner Toilette raus. Wenn ich unten aus einer Kabine vier Beine rausschauen sehe, sage ich nur: ‚Schluss jetzt, raus hier, oder ich hol die Polizei.' Dieselben Typen kommen immer wieder, Weiße, Asiaten, Schwarze. Deshalb muss ich hier immer aufpassen, jeden Tag von 7.30 Uhr bis 18 Uhr abends." Der Klowärter arbeitet seit 1986 in der öffentlichen Toilette am Stephenson Place, Birmingham, Großbritannien. Sein Name bleibt trotzdem ein Geheimnis.

« **Le** gros problème ici, et c'en est vraiment un, ce sont les homos. Non pas que j'aie quoi que ce soit contre les homos, mais il y en a qui viennent ici, qui rôdent autour des toilettes pour draguer et quelquefois on en retrouve deux dans une cabine. Je n'aime pas ça. Je les vire à coups de pied. D'abord, le règlement interdit qu'on soit deux par cabine. Si tu te lèves un mec, tu dégages de mes toilettes et tu vas faire ça ailleurs ! Quand j'aperçois quatre jambes sous la porte, je dis juste, "Hé, vous deux, vous sortez de là ou j'appelle les flics !" C'est toujours les mêmes têtes qu'on voit se pointer. Il y a des Blancs, des Asiatiques, des Noirs… C'est pour ça qu'il faut que je surveille constamment les toilettes, tous les jours, de 7h30 le matin à 6 heures du soir. » Ce Monsieur Pipi travaille depuis 1986 dans les toilettes publiques de Stephenson Place, à Birmingham (Royaume-Uni). Son nom reste cependant un mystère.

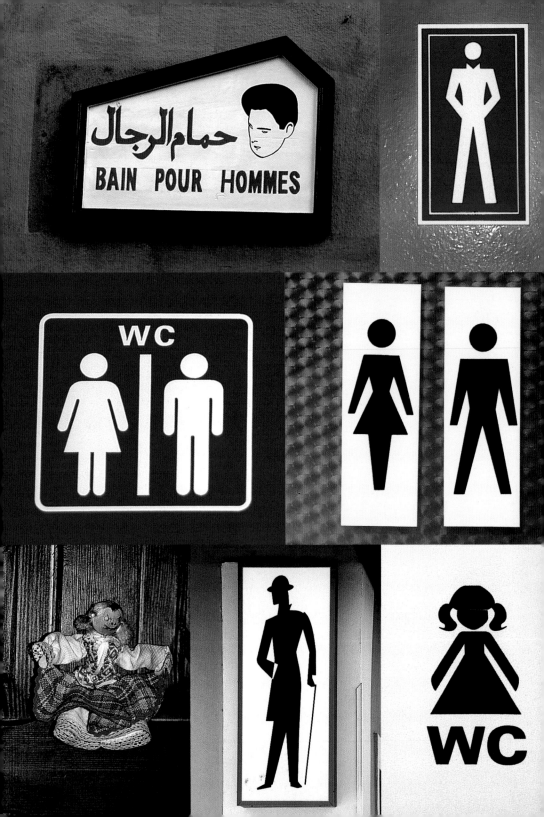

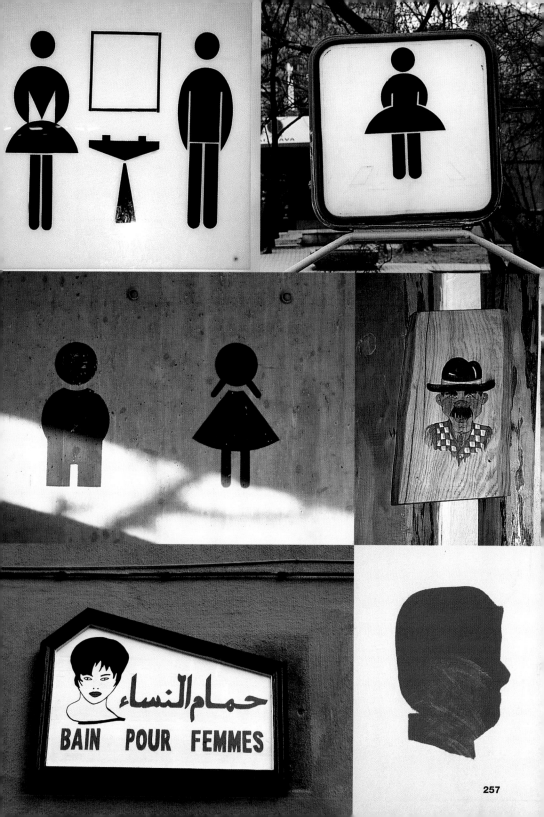

BAIN POUR FEMMES

**259
No!
Nein!
Non!**

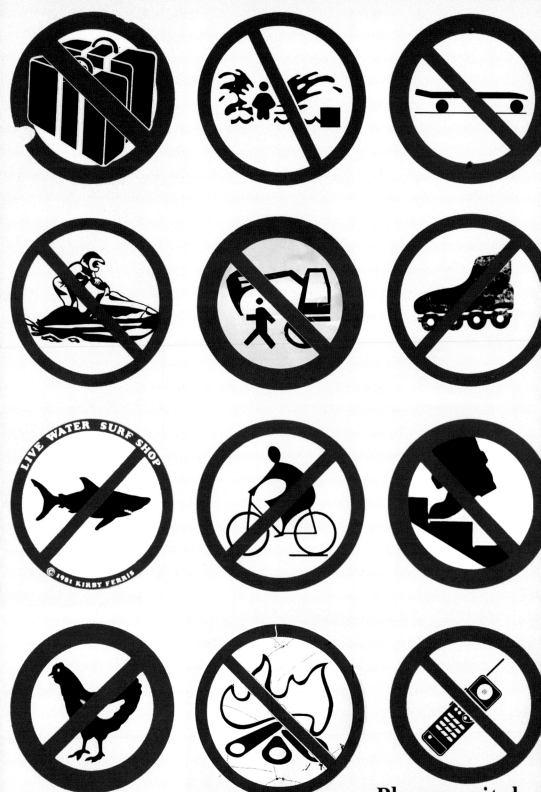

Please switch o

不准擺賣

VIETATO FUMARE

UNS OR ARCHERY **NO ENTRY** ห้ามหาบเร่

NO SCOOTERS

ห้ามวัตถุไวไฟ

MODEL AEROPLANES

WARNING

No swearing
Nicht fluchen
Ne jurez pas

Watch your mouth. In 1999, a 26-year old computer programmer called Timothy Boomer was charged with cursing in front of children after he fell out of a canoe in Michigan, US. Acting on a century-old state law on "indecent, immoral, obscene, vulgar or insulting" language within the earshot of women or children, Boomer was ordered to pay a US$75 fine and sentenced to four days' community service. But Boomer saw the sentence as going against the US First Amendment and the right of free speech, and took his case to the appeals court. He was pardoned, but had already gained a reputation in his hometown as the "cussing canoeist." "I'm a little more careful what I say in public these days," Boomer told journalists after the decision. "I don't think I will ever live this down completely."

Hüte deine Zunge. 1999 wurde der 26-jährige Programmierer Timothy Boomer angezeigt, weil er, als er in Michigan (USA) aus einem Kanu fiel, vor einem Kind geflucht hatte. Aufgrund eines alten Gesetzes, das im Staat Michigan den Gebrauch von „unanständigen, unmoralischen, obszönen, vulgären oder beleidigenden" Ausdrücken in Anwesenheit von Frauen oder Kindern bestraft, wurde Boomer zu einer Geldstrafe von 75 US$ und zu vier Tagen Sozialdienst verdonnert. Boomer erkannte in dem Urteil jedoch einen Verstoß gegen das Erste Amendement und das Recht auf freie Meinungsäußerung und brachte den Fall vor ein Berufungsgericht. Er wurde freigesprochen, hatte aber in seiner Heimatstadt den Ruf als „fluchender Paddler" weg. „Heute passe ich auf, wie ich mich öffentlich äußere", erklärte Boomer nach seinem Freispruch vor Journalisten. „Ich glaube nicht, dass ich jemals ganz davon wegkommen werde."

Surveillez votre langage. En 1999, un certain Timothy Boomer, 26 ans, programmateur informatique de son état, a été condamné pour avoir pesté et juré devant des enfants après être tombé de son canoë, au Michigan (États-Unis). Sur la base d'une loi d'État vieille d'un siècle, sanctionnant tous propos «indécents, immoraux, obscènes, vulgaires ou insultants» susceptibles d'être entendus par des femmes ou des enfants, Boomer dut payer une amende de 75$US et effectuer quatre jours de travaux d'utilité publique. Estimant néanmoins qu'une telle sanction constituait une infraction au Premier amendement de la Constitution américaine et une atteinte à la liberté de parole, il fit appel et fut gracié, mais le mal était fait, puisqu'il s'était déjà acquis, dans la ville où il résidait, une solide réputation de «canoéiste jureur». «À présent, je fais un peu plus attention à ce que je dis en public, confia Boomer aux journalistes après que la cour d'appel eut rendu son verdict. Je ne crois pas que je pourrai jamais oublier ce qui s'est passé.»

Hands free
Freihändig
Mains libres

Driving while holding and talking on your mobile phone slows your reaction times by 50 percent, according to 2002 research by the UK's Transport Research Laboratory. (By contrast, being just over the legal alcohol limit slows them by 30 percent.) So in December 2003, the UK joined over 30 other countries and banned driving while using a mobile phone, except if a hands-free kit is fitted. With over 24 million mobile telephones in the country—more than one per household—and one in four drivers saying they'll ignore the law, the police are going to be busy handing out UK£30 (US$52) fines. And don't think that just pulling over the side of the road to take your call is enough. According to the law, you're still driving—even if you're not moving—whenever your engine is running.

Wenn du beim Autofahren dein Handy ans Ohr hältst und telefonierst, verringert sich deine Reaktionszeit um bis zu 50%. Das geht aus einer Studie des britischen Verkehrsforschungsinstituts aus dem Jahre 2002 hervor. (Dagegen verringert eine geringfügig über der gesetzlichen Promille-Grenze liegende Alkoholmenge die Reaktionszeit lediglich um 30%.) Infolgedessen schloss sich Großbritannien im Dezember 2003 weiteren 30 Ländern an, die den Gebrauch von Mobiltelefonen im Auto nur noch mittels Freisprechanlagen gestatten. Da im ganzen Land über 24 Millionen Handys – mehr als eins pro Haushalt – in Gebrauch sind und einer von vier Autofahrern angibt, er werde das Verbot nicht beachten, bereiten sich Polizeistreifen darauf vor, bündelweise Strafmandate über 30 Pfund (52 US$) auszustellen. Und glaub ja nicht, es reichte, zum Telefonieren kurz rechts ran zu fahren: Nach dem Gesetz fährst du, solange der Motor läuft – auch wenn du dich nicht fortbewegst.

Téléphoner au volant ralentit de 50 % votre temps de réaction, nous révèle une étude menée en 2002 par le Laboratoire britannique de recherche sur les transports. (Par comparaison, si vous vous trouvez juste au-dessus du taux d'alcoolémie autorisé, la perte de réactivité n'est que de 30 %.) Aussi le Royaume-Uni a-t-il rejoint en décembre 2003 les rangs des nombreux États (plus de 30 à ce jour) qui ont proscrit l'usage du téléphone au volant, à moins d'être équipé d'un kit mains-libres. Toutefois, dans un pays où l'on recense 24 millions de téléphones mobiles (soit plus de un par famille) et où un automobiliste sur quatre annonce ouvertement qu'il passera outre l'interdiction, la police a du pain sur la planche et n'a pas fini de distribuer des amendes de 30 £ (52 $ US). Et ne vous croyez pas tiré d'affaires sous prétexte que vous avez pris soin de vous arrêter sur le bas-côté: aux termes de la loi, vous êtes en situation de conduite tant que votre moteur n'est pas éteint.

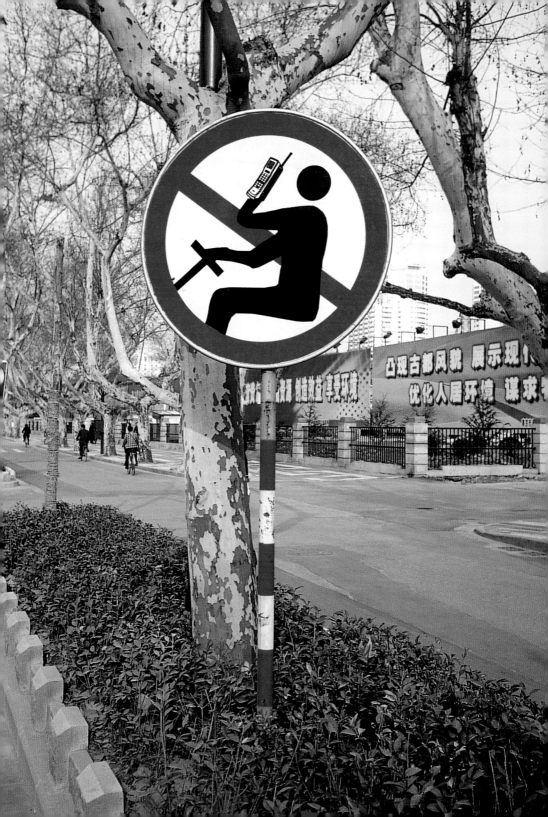

Thumbs up
Daumen hoch
Haut les pouces

Hitchhiking is illegal in many parts of the world, including Tibet and most European highways. But don't despair. In 1995, Valery Shanin founded the Moscow School of Hitchhiking, where you can meet people and find out more about the art. He has since hitched around the world, after leaving home with only US$300 in his pocket. Shanin wants people who can't afford to travel by conventional means—and in particular Russians, who rarely travel independently—to feel like they can explore the world and its people. Be careful, though: While the thumbs-up sign means "you're great," "well done" or "I'm OK" in many parts of the world, in Bangladesh, Ghana, Nigeria, Iran and Russia, an erect thumb means "stick it up your ass."

Per Anhalter zu reisen ist in vielen Teilen der Welt illegal, unter anderem in Tibet und auf den meisten europäischen Autobahnen. Aber das ist kein Grund zur Verzweiflung. Der Russe Valerij Schanin gründete 1995 die Moskauer Akademie für Tramper, an der du Gleichgesinnte treffen und dich mit den Tricks des Metiers vertraut machen kannst. Valerij ist mit nur 300 US$ in der Tasche durch die ganze Welt getrampt. Er möchte Leuten (vor allem Russen, die in der Regel nicht auf eigene Faust reisen) das Gefühl vermitteln, die Welt und ihre Menschen kennen lernen zu können, selbst wenn sie es sich nicht leisten können, mit konventionellen Mitteln zu reisen. Sei jedoch vorsichtig: Während in vielen Teilen der Welt ein hochgereckter Daumen „du bist okay", „gut gemacht" oder „alles klar" bedeutet, ist das nicht überall so. In Bangladesch, Ghana, Nigeria, im Iran und in Russland heißt das Zeichen: „Den kannst du dir in den Hintern stecken."

L'auto-stop est certes prohibé dans bien des régions du monde – au Tibet, par exemple, ou sur la plupart des autoroutes européennes –, mais ne perdez pas espoir. En 1995, Valery Chanin a fondé son École du stop de Moscou, véritable vivier de gens à rencontrer et de choses à savoir pour mieux cultiver cette façon de voyager. Valery allie théorie et pratique, puisque, parti de chez lui avec seulement 300 $US en poche, il a réalisé un tour du monde en auto-stop. Il souhaite insuffler à tous ceux qui ne peuvent se permettre de voyager de façon conventionnelle – et en particulier aux Russes qui ne se déplacent jamais de façon indépendante – le désir et le courage d'explorer le monde à la rencontre de ses peuples. Prudence toutefois : si, dans de nombreux pays, le pouce levé signifie « bravo », « vous êtes génial » ou « je vais bien », il pourrait vous créer des ennuis au Bangladesh, au Ghana, au Nigeria, en Iran ou en Russie, où il signifie « mets-toi ça dans le cul ».

Clothing optional
Kein Kleiderzwang
Vêtements facultatifs

"**Clothing** optional" is the term preferred by naturists for their pastime. In Florida, USA, the law doesn't actually criminalize nudity ("It is unlawful to expose or exhibit one's sexual organs in public [...] in a vulgar or indecent manner, or to be naked in public except in any place provided or set apart for that purpose"), but that doesn't mean it was easy convincing the authorities that naturists should have their own beach. Just down the road from Miami's celebrated South Beach, it's the only clothing optional beach in Florida.

„**Kein** Kleiderzwang" – mit dieser Wendung bezeichnen die Anhänger der Freikörperkultur ihr Hobby am liebsten. In der Gesetzgebung des Staates Florida (USA) gilt Nacktheit nicht ausdrücklich als Verbrechen („Es verstößt gegen das Gesetz, seine Geschlechtsorgane in der Öffentlichkeit auf vulgäre oder unanständige Weise zu zeigen oder zur Schau zu stellen oder sich unbekleidet in der Öffentlichkeit aufzuhalten, außer an Plätzen, die eigens dafür eingerichtet oder zu diesem Zweck reserviert sind"), aber das reichte bei weitem nicht aus, die Behörden von der Notwendigkeit eines FKK-Strandes zu überzeugen. Nicht weit von Miamis berühmtem South Beach liegt der einzige Strand, an dem kein Kleiderzwang herrscht.

« **Vêtements** facultatifs » : tel est le terme le plus prisé des naturistes pour désigner leur passetemps favori. En Floride (États-Unis), la loi ne criminalise pas exactement la nudité en tant que telle (« Il est interdit d'exposer ou d'exhiber en public ses organes sexuels [...] de façon vulgaire ou indécente ou de se montrer nu en public ailleurs que dans les lieux spécifiquement désignés ou réservés à cet effet »), mais de là à convaincre les autorités que les naturistes devaient absolument avoir leur plage… C'est pourtant le cas : à quelques centaines de mètres de la célèbre South Beach de Miami se trouve la seule plage de Floride où les vêtements restent optionnels.

No smoking

Voodoo
Voodoo
Vaudou

Voodoo is a blend of Catholic and traditional African beliefs that's popular in the Caribbean and the Americas. In Haiti, a ritual mud bath is performed every July; honey and herbs in the mud draw out sickness, and possessions (voodoo deities) swim around in it, ready to possess bathers. Devotees can rub mud on each other, but being touched by priests is holier still. "To make you a priest or high priestess," explains Gro Mambo, a voodoo priestess at Le Peristyle Haitian Sanctuary in Philadelphia, USA, "they burn medicines and put them in your hands, and hold your hands shut. We have to have our hands burned to touch people, bathe them, lay hands on them and heal them."

Voodoo ist eine Mischung aus Katholizismus und traditionellen afrikanischen Stammesriten, die in den Karibikländern und auf dem amerikanischen Doppelkon-tinent verbreitet ist. In Haiti nehmen Anhänger jedes Jahr im Juli ein rituelles Schlammbad: Der mit Honig und Kräutern vermischte Schlamm befreit den Körper von Krankheiten, und Voodoo-Gottheiten warten darin auf eine günstige Gelegenheit, in die badenden Gläubigen „einzufahren". Die Anhänger können sich gegenseitig mit Schlamm einreiben, aber noch heiliger ist die Berührung durch einen Priester. „Um einen Gläubigen zum Priester oder zur Priesterin zu weihen, legt man ihm oder ihr brennende Kräuter in die Hände und hält sie geschlossen", erklärt Gro Mambo, Voodoo-Priesterin am haitianischen Tempel Le Peristyle in Philadelphia (USA). „Wir müssen uns die Hände verbrennen, um andere zu berühren, sie zu baden und sie durch Handauflegen zu heilen."

Mélange de pratiques magiques africaines et d'éléments emprun-tés au rituel chrétien, le vaudou est répandu chez les Noirs des Antilles et des deux Amériques. À Haïti, le bain de boue rituel est de rigueur chaque mois de juillet. Le miel et les herbes qu'il contient chassent les maladies, et les « possessions » (ou déités vaudoues) viennent y nager, à l'affût d'un baigneur à posséder. Les fidèles peuvent bien entendu s'enduire mutuellement de boue, mais la consécration suprême reste l'attouchement d'un prêtre. « Lorsqu'on ordonne un prêtre ou une grande prêtresse, explique Gro Mambo, elle-même prêtresse vaudoue au sanctuaire haïtien Le Péristyle de Philadelphie (États-Unis), on brûle des plantes médicinales et on les place dans ses mains, puis on lui maintient les poings fermés. Pour toucher les gens, pour les baigner, pour les soigner, pour leur faire l'imposition des mains, il faut avoir les paumes brûlées. »

No rafts
Keine Boote
Radeaux interdits

Since mid-2001, around 100 Dominicans have died in the 130-km Mona Passage that separates the Dominican Republic from the US territory of Puerto Rico on homemade boats called *yolas*. (From there, migrants can enter the US mainland with less stringent immigration checks.) "Yolas are poorly constructed small wooden vessels, typically about 4-9m long, with a small horsepower outboard engine," says Zulma Nieves from the US Coast Guard in Puerto Rico. "They do not have marine radios, navigation lights, or any other navigation equipment on board. However, a typical yola makes the transit in 24-30 hours. The most important thing for migrants to bring with them is water. As for food, they usually bring boiled eggs, canned meats and other nonperishable food items. There was one case this year where a yola was disabled and adrift for approximately 10-14 days with 16 migrants onboard. Apparently they survived by drinking the breast milk from a lactating mother within the group."

Seit Mitte 2001 sind etwa 100 Dominikaner bei dem Versuch ums Leben gekommen, die 130 km breite Mona-Passage zwischen der Dominikanischen Republik und dem US-amerikanischen Protektorat Puerto Rico (von wo aus bessere Chancen bestehen, ohne allzu gründliche Kontrollen in die USA einzureisen) in selbst gezimmerten Booten zu überqueren, die als *yolas* bezeichnet werden. „*Yolas* sind zusammengehauene Nussschalen von durchschnittlich 4 bis 9 m Länge mit einem leistungsschwachen Außenbordmotor", erklärt Zulma Nieves von der puertoricanischen Küstenwache. „Sie haben weder Funkradios, Positionslichter noch irgendwelche Navigationsinstrumente an Bord. Trotzdem legt ein typisches *yola* die Strecke in 24 bis 30 Stunden zurück. Der wichtigste Teil des Proviants ist Wasser. Zum Essen haben die Passagiere meistens hart gekochte Eier, Büchsenfleisch und andere unverderbliche Nahrungsmittel dabei. Einmal fiel bei einem *yola* der Motor aus, und es trieb fast zwei Wochen lang mit 16 Personen an Bord im Meer. Sie überlebten, weil eine stillende Mutter dabei war, deren Milch sie tranken."

Depuis l'été 2001, près de 100 Dominicains ont trouvé la mort alors qu'ils tentaient de traverser le passage de Mona (un détroit large de 130 km, séparant la République dominicaine de Porto Rico), à bord d'esquifs de fortune appelés *yolas*. Porto Rico étant en effet un territoire américain, les migrants qui parviennent jusquelà peuvent ensuite pénétrer plus facilement aux États-Unis, à la faveur de contrôles d'immigration moins stricts. «Les *yolas* sont de petits bateaux en bois, peu solides, construits à la va-vite. Elles font en général entre 4 et 9m de long et sont équipées d'un moteur hors-bord de faible puissance, explique Zulma Nieves, de la brigade des gardes-côtes américains stationnée à Porto Rico. Elles n'ont pas de radio à bord, pas de feux de navigation, ni aucun autre équipement, d'ailleurs. Mais enfin, une *yola* type arrive tout de même à traverser en 24 à 30 heures. Le plus important, pour les migrants, c'est d'emporter des réserves d'eau. Ils embarquent aussi quelques vivres, généralement des œufs durs, de la viande en boîte – des aliments non périssables. Nous avons eu cette année le cas d'une *yola* qui, à la suite d'une avarie, a dérivé pendant 10 à 14 jours, avec 16 migrants à son bord. À ce qu'il semble, ils ont survécu en buvant le lait d'une mère qui allaitait et qui se trouvait parmi eux. »

No parking
Parkverbot
Stationnement interdit

Pearl earrings and lipstick are now required uniform for traffic police in Lima, Peru. That's because the government decided it wanted a 100 percent female force. Designed to fight corruption—women, it seems, are less likely to take bribes—the measure has proved unpopular with Lima's male drivers, who aren't happy taking orders from women. In the first half of 2002, female traffic police (who now make up 73 percent of the force) accounted for 90 percent of the 137 reported abuse cases. "Last year, I was directing traffic when I realized a Combi [van] had stopped at a green light," says Anamelba Mejia Siguenas, 28. "I signaled for the driver to move on, but he didn't. I approached him, asked for his license and told him to pull up on the right. I then gave him a ticket for not obeying a police officer, but he refused to sign it. When I handed back his license, he grabbed my arm and said, 'You should die and be run over because you're a bitch,' and then accelerated. He drove for two blocks, then dropped me. Another Combi driver rammed into me, dislocating my left shoulder, and then a taxi slammed on its brakes and hit me in the face. My uniform was destroyed. My tickets flew all over the place and cars were all around me. My coworkers followed [the Combi driver] and one of them caught him. He was taken to the police station. But he's not in jail and I'm still in treatment."

Perlenohrringe und Lippenstift gehören bei der Verkehrspolizei in Lima (Peru) zur Dienstkleidung, seit die Regierung beschlossen hat, ausschließlich weibliche Ordnungshüter zu beschäftigen. Die Maßnahme gehört zur Kampagne gegen die Korruption – anscheinend sind Frauen weniger bestechlich als Männer – und ist bei den männlichen Autofahrern, die ungern Befehle von Frauen entgegennehmen, alles andere als beliebt. In den ersten sechs Monaten des Jahres 2002 waren bei den 137 Fällen von Gewaltanwendung gegen Polizisten 90% der Opfer weibliche Beamte (die mittlerweile 73% des gesamten Polizeikorps stellen). „Als ich einmal im letzten Jahr den Verkehr regelte, bemerkte ich einen Lieferwagen, der an einer grünen Ampel hielt", erzählt Anamelba Mejia Siguenas (28). „Ich bedeutete dem Fahrer, weiterzufahren, aber er reagierte nicht. Ich ging zu ihm hin und forderte ihn auf, mir seinen Führerschein zu zeigen und an den Bordstein zu fahren. Dann stellte ich wegen Ungehorsam gegenüber einem Polizeibeamten ein Strafmandat aus, aber er weigerte sich, es zu unterschreiben. Als ich ihm seine Papiere zurückgab, packte er meinen Arm, schrie ‚Du sollst unter ein Auto kommen und krepieren, du Nutte' und fuhr los. Nach zwei Häuserblocks ließ er mich fallen. Ich wurde von einem anderen Lieferwagen angefahren und kugelte mir dabei die Schulter aus, ein Taxi konnte gerade noch bremsen, erwischte mich aber im Gesicht. Meine Uniform war hin. Überall flogen Strafzettel herum, und ich lag mitten zwischen den Autos. Meine Kollegen verfolgten den Fahrer, einer schnappte ihn und brachte ihn aufs Revier. Aber ins Gefängnis kam er nicht, und ich bin immer noch in medizinischer Behandlung."

Chez les agents de la circulation de Lima (Pérou), boucles d'oreilles en perles et rouge à lèvres font désormais partie de l'uniforme, le gouvernement ayant décidé de féminiser entièrement cette brigade. Cette mesure, destinée à combattre la corruption (les femmes sont moins enclines, semblerait-il, à accepter les pots-de-vin), n'est manifestement pas appréciée des

automobilistes mâles de la capitale, peu disposés à recevoir des ordres d'une femme. Au cours du premier semestre 2002, les préposées à la circulation (qui représentent pour l'heure 73 % de la brigade) avaient fait l'objet de 90 % des 137 cas d'agressions répertoriés. «L'année dernière, j'étais en train de faire la circulation quand, tout à coup, je me suis rendue compte qu'un [fourgon] Combi venait de s'arrêter à un feu vert, raconte Anamelba Mejia Siguenas, 28 ans. Je fais signe au conducteur de circuler, mais il m'ignore. Je m'approche, je lui demande son permis et je lui dis de se garer sur le bas-côté. Je lui dresse procès-verbal pour refus d'obéissance à agent, mais il refuse de le signer. Au moment où je lui rendais son permis, il m'a agrippée par le bras en disant, "Crève donc et fais-toi rouler dessus, salope !" Et il a accéléré. Il m'a traînée sur deux pâtés de maison avant de me lâcher. Un autre Combi m'a lors percutée, il m'a démis l'épaule gauche, ensuite un taxi a pilé pratiquement sur moi et m'a heurtée au visage. Mon uniforme était en pièces, mes tickets de contraventions volaient dans tous les sens, j'étais au milieu des voitures… Pendant ce temps, mes collègues poursuivaient [le conducteur du Combi]. L'un d'eux a réussi à le rattraper. Il a été emmené au poste, mais il n'est pas en prison et moi, je suis encore sous traitement. »

301
Work
Arbeit
Travail

Men at work
Arbeiter
Chantier en cours

The future of humankind is underground. Subterranean real estate is inexpensive, weatherproof, energy-efficient and insulated from the sun's harmful rays. Stockholm, which already has an underground concert hall, plans subterranean pedestrian paths by the end of the century. With Tokyo bursting at the seams, Japan's gigantic Tokyu construction company has unveiled designs for an underground city, Geotropolis, to be habitable by the year 2020. And dozens of countries, including Scotland and Northern Ireland, are making plans to hook up by underwater tunnels.

Subterranean construction will mean lots of new jobs for people with the right skills. To learn how to operate the most advanced tunneling equipment (gigantic digging machines that bore up to 3.3cm of tunnel per minute), look for work in one of the many subways now in progress worldwide (London, Paris, Cairo, Lisbon, Toronto, Brasilia and Rome all have projects under way). As Rafik Karaouzen, a tunneler in the Cairo subway, told us, a prospective tunneler "should not be scared of working in tight, hot, closed-in places, nor mind getting dirty." Salaries are good in comparison with most construction jobs, but beware of the risks: The high atmospheric pressure in tunnels (a result of air pumped in to prevent leakage) can lead to bone disease and lung trouble; carbon monoxide frequently reaches danger levels; and tunnel construction generally leaves one person dead every 1.6 kms.

Die Zukunft der Menschheit liegt unter der Erde. Unterirdische Immobilien sind billig, wetterfest, energiesparend und keinen schädlichen Sonnenstrahlen ausgesetzt. In Stockholm, das schon heute einen unterirdischen Konzertsaal hat, ist geplant, bis zum Ende des Jahrhunderts Fußgängerzonen unter Tage einzurichten. Für das überfüllte Tokio hat die Großbaufirma Tokyu Entwürfe für eine Untergrundstadt, Geotropolis, vorgelegt, die spätestens im Jahr 2020 beziehbar sein soll. Und in Dutzenden anderer Länder, darunter Schottland und Nordirland, werden Pläne für Unterwasser-Tunnelverbindungen geschmiedet.

Auf Baustellen unter Tage gibt es für Leute mit den richtigen Qualifikationen jede Menge Arbeitsplätze. Wenn ihr lernen wollt, wie man mit den modernsten Tunnelvortriebsmaschinen (riesigen Bohrern, die pro Minute bis zu 3,3 cm Erde aushöhlen) umgeht, bewerbt euch auf einer der vielen U-Bahn-Baustellen der Welt (London, Paris, Kairo, Lissabon, Toronto, Brasilia und Rom erweitern zurzeit das Tunnelnetz). Rafik Karaouzen von der Kairoer U-Bahn meint, ein zukünftiger Tunnelgräber dürfe „nicht davor zurückschrecken, an engen, heißen, schwer zugänglichen Orten zu arbeiten und vor allem sich schmutzig zu machen". Das Lohnniveau liegt im Vergleich zu anderen Großbaustellen relativ hoch, dasselbe gilt aber für das Berufsrisiko: Der hohe Luftdruck in Tunneln (der auf die zugepumpte Luft, die Erdgeriesel verhindern soll, zurückzuführen ist) kann zu Knochenschäden und Lungenbeschwerden führen. Kohlenmonoxid erreicht oft bedenkliche Werte, und im Schnitt bleibt beim Tunnelbau alle 1,6 km wortwörtlich ein Arbeiter auf der Strecke.

L'avenir de l'homme est sous la terre. Songez plutôt : l'immobilier souterrain est peu coûteux, résistant aux intempéries, facile à chauffer et protégé des rayons nocifs du soleil. Stockholm, qui dispose déjà d'une salle de concert souterraine, projette de creuser des rues piétonnes sous

terre. Pour désengorger Tokyo, si surpeuplée qu'elle semble proche du point de rupture, l'énorme entreprise japonaise de BTP Tokyu a dévoilé les plans d'une cité souterraine, Geotropolis, qui serait habitable aux alentours de 2020. Des dizaines d'autres pays, notamment l'Écosse et l'Ulster, se lancent dans des projets de liaison par tunnel sous-marin.

Le domaine de la construction souterraine générera une manne de nouveaux emplois – pour ceux, bien entendu, qui présenteront les aptitudes requises. Alors, n'hésitez plus : initiez-vous dès à présent au fonctionnement des tunneliers les plus modernes et performants (ces gigantesques machines qui forent jusqu'à 3,3 cm de tunnel à la minute) en décrochant un emploi dans l'un des nombreux métros en chantier dans le monde (les villes de Londres, Paris, Le Caire, Lisbonne, Toronto, Brasilia et Rome ont toutes des projets en cours). Comme nous l'a expliqué Rafik Karaouzen, tunnelier dans le métro du Caire, un futur tunnelier « ne doit pas avoir peur du manque d'espace et des endroits confinés, ni craindre la chaleur et la saleté. » Les salaires sont avantageux, comparés à ceux habituellement pratiqués dans le BTP, mais attention aux risques : la forte pression atmosphérique qui règne dans les tunnels (en raison de l'air pulsé que l'on y introduit afin d'éviter les fuites) peut provoquer des maladies osseuses et des troubles respiratoires ; le monoxyde de carbone y atteint souvent des niveaux de concentration dangereux ; enfin, la construction des tunnels fait en moyenne un mort tous les 1,6 km.

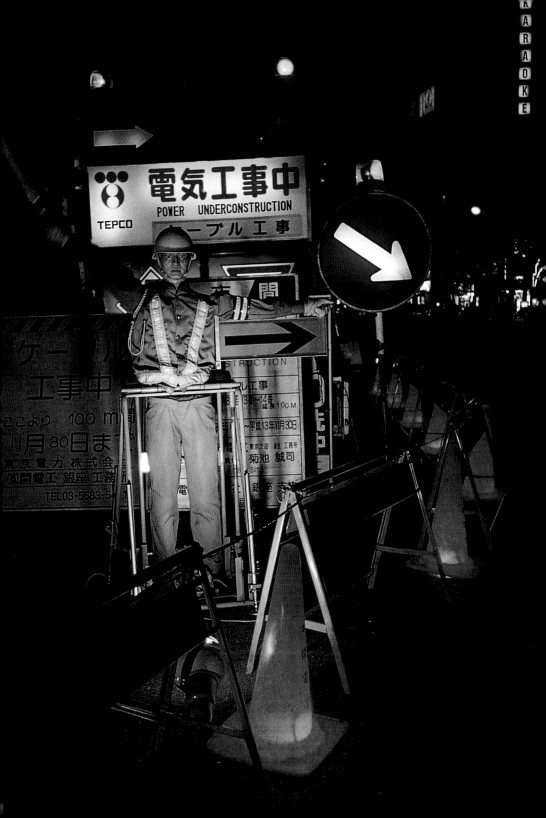

To take advantage of cheap labor and lax environmental laws, US multinational companies have set up some 2,000 *maquiladoras*, or factories, along the Mexico-USA border. Every week thousands of young women find work in the maquiladoras. They settle in shantytowns close to the factories, with no fresh drinking water or sewage and household waste treatment facilities. Illegal dumping and industrial spillages have contaminated water supplies with dangerous levels of sulfates and arsenic—skin disorders, hepatitis A, dysentery and asthma are widespread. Companies require pregnancy tests before hiring, and workers who do become pregnant may face serious problems. Birth defects such as anencephaly (when most of the brain is missing) and encephalitis (excess brain fluid that causes swelling) are common. Though these defects are five times more prevalent along the Mexico-USA border than in the USA as a whole, multinationals insist that environmental conditions around the maquiladoras are not to blame.

Um die großzügigen Umweltgesetze und die billigen Arbeitskräfte in Mexiko auszunützen, haben US-Großkonzerne ca. 2000 *ma-quiladoras* oder Fabriken entlang der Grenze zwischen Mexiko und den USA eingerichtet. Jede Woche finden Tausende junger Frauen dort Arbeit. Sie ziehen in Hüttensiedlungen ohne Trinkwasserversorgung, Kanalisation oder Müllentsorgungsmöglichkeite in der Nähe der Fabriken. Illegale Abfallentsorgung und Industriemüll haben das Grundwasser hochgradig mit Sulfaten und Arsen verseucht: Hautkrankheiten, Hepatitis A, Ruhr und Asthma sind weit verbreitet. Die Firmen verlangen einen Schwangerschaftstest vor jeder Einstellung, und Arbeiterinnen, die schwanger werden, gehen beträchtliche Risiken ein. Geburtsschäden wie Anenzephalie (bei der dem Baby das Gehirn größtenteils fehlt) und Wasserkopf (übermäßige Ansammlung von Gehirnflüssigkeit) kommen häufig vor. Obwohl diese Schäden an der Grenze zwischen Mexiko und den USA fünfmal häufiger auftreten als in den gesamten USA, bestehen die Konzerne darauf, dass an den Umweltbedingungen um die *maquiladoras* nichts auszusetzen sei.

Profitant du laxisme des lois sur l'environnement au Mexique et du coût avantageux de la main-d'œuvre locale, certaines multinationales américaines ont installé le long de la frontière mexicaine quelque 2000 *maquiladoras* (usines). Chaque semaine, des milliers de jeunes femmes y sont embauchées. Elles s'installent à proximité, dans des bidonvilles sans eau potable, sans système d'évacuation ni enlèvement d'ordures. Les décharges sauvages et le déversement anarchique, souvent accidentel, de déchets industriels ont contaminé le réseau d'eau, dont la teneur en sulfates et en arsenic est devenue alarmante. Affections cutanées, hépatite A, dysenterie, asthme sont désormais monnaie courante. Lors de l'embauche, on impose aux femmes un test de grossesse. Quant aux employées qui tombent enceintes, elles sont parfois confrontées à de sérieux problèmes. En effet, les malformations génitales abondent, en particulier les anencéphalies (absence quasi totale d'encéphale) et les encéphalites (excès de liquide céphalique entraînant des œdèmes). Bien que ces anomalies soient cinq fois plus nombreuses dans cette zone frontalière que sur l'ensemble du territoire américain, les multinationales persistent à mettre hors de cause l'état de l'environnement autour des *maquiladoras*.

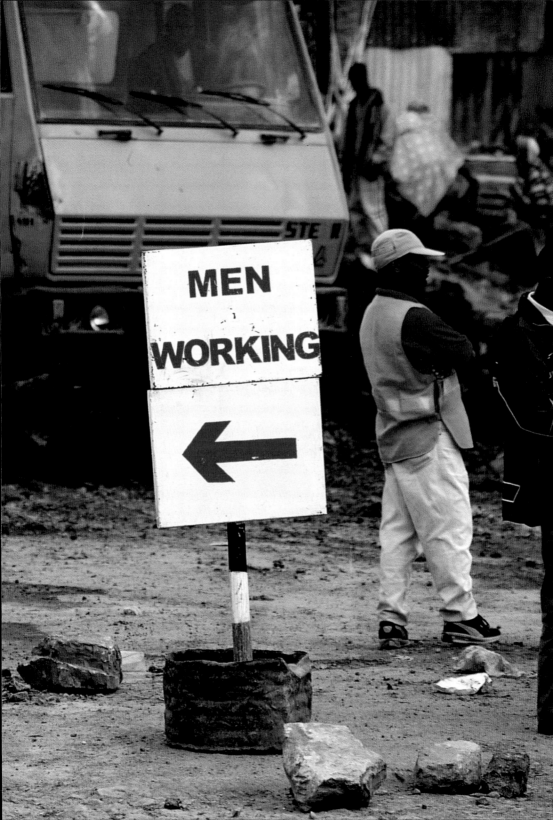

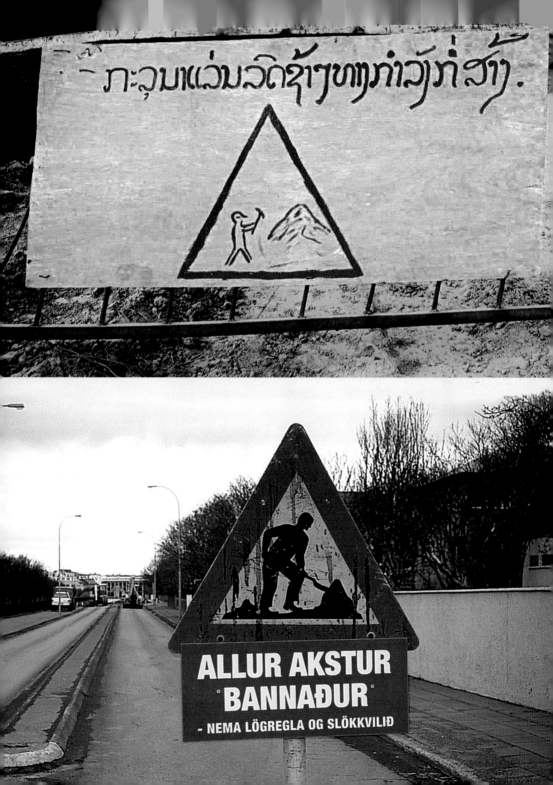

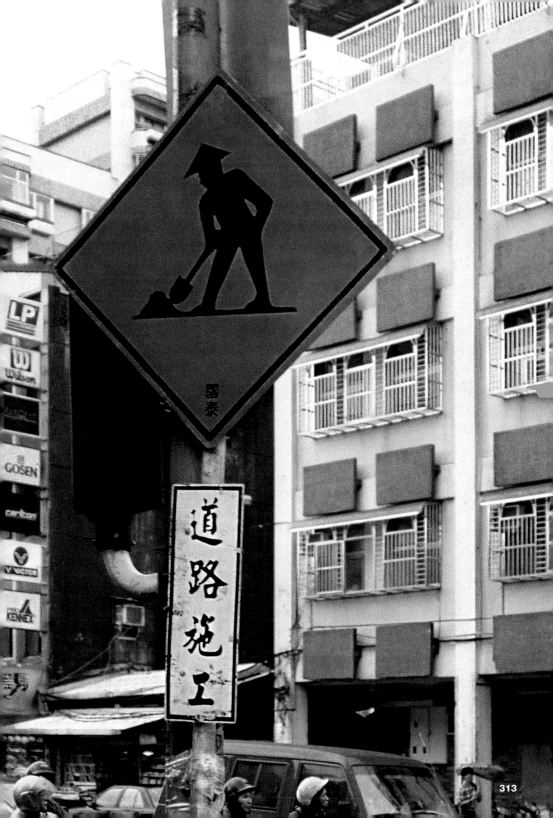

Photographers
Photographes
Fotografen

Julius Ananura
Uganda 45[2], 171, 188[1], 294[6], 297
Nadim Asfar
Lebanon 175, 209, 256[7]
Jack Barker
Mauritania 8; Morocco 94; Indonesia 108[4];
Namibia 279
Grégoire Basdevant
Laos 60, 179[8], 308[1], 309[1]; Morocco 129,
212[3], 256[1]; France 131[6], 256[3], 257[5],
265[3]; Egypt 156, 179[6], 285[11], 294[1];
Mexico 187[1]; USA 268; Spain 294[5]
Martin Basdevant
Mexico 264[4]
Sadhna Baskali
South Africa 100
Michela Beccacece
Italy 85[4]
Patrizia Benvenuti
China 217, 285[3]
Arthur Binard
South Korea 68[6]; Japan 79, 112[3], 125[2]
Lucía Bruno
Uruguay 140[1], 222
Rahmat Buwantoro
Indonesia 31, 108[3], 109, 114[1], 135, 198[2]
Marco Callegari
Italy 44, 47[2], 69[9], 98, 131[10],
179[12], 188[3], 193, 194[2], 213, 263[3],
263[7], 285[2]; Austria 241, 257[3]
Jasmin Chua
Australia 74[2]
Anne Cline
Australia 10
Paulo Condez
Italy 125[1]
John Cunningham
USA 20[5]

Dejan Djuric and Djordje Nenadovic
Serbia-Montenegro 299
Julie Denesha
Czech Republic 298
Neha Diddee
India 136, 294[4]
Alejandro Duque
Colombia 68[1], 114[5]
Rasa Erentaite
Lithuania 85[2], 112[1], 205, 256[5], 257[2],
257[4]
S. Galt
Laos 69[5], 69[6], 112[9], 125[4], 179[10],
179[2], 257[6]
Rose George
Irak 68[5], 285[9]
Tefera Ghedamu
Ethiopia 69[1], 112[4], 188[2], 188[7], 293, 307
L. Glennie
Santa Lucia 8
Lucy Grin
Russia 99, 111, 112[11], 114[9], 118, 131[1],
256[6], 262[11], 285[8], 309
Barbara Gurney
Australia 13[4], 20[4], 85[1]
András Hajdu
Hungary 25, 263[11], 263[9], 264[12], 265[8]
Patrice Hanicotte
USA 28; France 114[2]
Jorge Heijo
Australia 20[3], 23, 53, 168, 262[12], 262[2],
263[10], 263[4], 264[10], 264[11], 264[1],
265[10], 265[11], 273
Pieter Hugo
Brazil 291
Francesca Jacchia
Germany 83[2], 262[6], 262[8], 264[3];
Hong Kong 245

Mandy Lee Jandrell
Hong Kong 21, 68[7], 125[3], 258, 284;
UK 212[6]
Kuo-chen Kao
Taiwan 312
Parag Kapashi
Germany 131[12], 179[1]
Ingvar Kenne
Australia 64
Martin Kennedy
UK 43
Erik Kessels
Italy 283
Jonathan Kress
New Zealand 13[2], 13[5], 13[6], 91[1], 119,
121, 140[4], 146, 166[10], 166[11], 166[1],
166[9], 169[7], 179[3], 179[7]
Chris Lane
USA 93
Ben Latto
Belgium 73, 263[6]; Mexico 140[2]; Iran 149, 252
Alex Lebeaun
Nepal 281; India 295
Dana Levy
Israel 41, 59, 300
Jerry Lin
Singapore 20[1], 47[1], 131[8], 222[1], 285[7]
Adrianna Linderman
USA 68[2], 262[7]
Tim and Sophie Loft
Cambodia 219[1]; Thailand 263[12], 264[5],
265[7]
John Maier
Ecuador 39; Brazil 113
Bernd Meyer
Namibia 66
Boris Missirkov and Georgi Bogdanov
Italy 187[2], 262[5]; Bulgaria 123; Croatia 256[2]

Amean Mohammed
Pakistan 3, 68[3], 108[1], 177, 178, 275, 294[8]
James Mollison
Colombia 26; Democratic Republic of Congo 151, 183; Kenya 69[8], 212[5], 269; France 81, 257[1]; Pakistan 105, 115; Russia 114[3], 189, 285[1]; China 179[9], 277; Japan 130, 147, 265[4], 305; Brazil 145; Cambodia 153; Sierra Leone 154; Ivory Coast 155; Cameroon 161; Italy 186, 188[4]; Hong Kong 263[1]
Duncan Moore and Marion Smallbones
Taiwan 89[2], 112[5]
Jodi Morrison
India 20[2]
Carlos Mustienes
Spain 48, 69[3], 108[2], 207, 204, 237[1], 251; Italy 75[2], 83[1], 97, 212[1], 212[4], 256[4], 263[8]; Slovenia 77; Thailand 234, 265[12]; Bosnia-Herzegovina 265[5]; USA 265[9]
Kim Naylor
Finland 19; Honduras 35, 63, 140[3], 166[12], 169[1], 169[2], 169[3], 201; Somalia 219[2], 228
Nick Nostitz
Thailand 34[1], 68[4], 166[8], 169[5], 172, 266
Eoin O'Mahony
Ireland 34[3], 84[4], 112[8], 131[2], 131[9], 141[1], 159, 166[2], 166[4], 169[4], 194[3], 194[4], 264[8], 264[9], 294[7]
Charlotte Østervang
Denmark 45[1], 86, 131[11]
Elena Paini
New Zealand 13[1]
Mila Pavan
Lybia 65

Borut Peterlin
Slovenia 114[7], 194[2], 195, 202
Tom Ridgway
Laos 89[1], 124, 133; Cambodia 69[7]; France 242
Stefan Ruiz
France 265[1], 285[4]; USA 34[2], 36, 91[4], 162, 167; Chile 220; UK 262[1], 309
Neli Ruzic
Mexico 112[2], 142, 169[6], 179[11], 180, 188[5], 230, 248
Simon Saliot
India 164
Darnell Sardinha
South Africa 80
Guy Saville
Thailand 69[4], 114[8]
Alvaro Silva
Puerto Rico 262[4], 294[3]
Martino Sorteni
Italy 198[1]
Paul Souders
Australia 15, 197; Chile 27; USA 210
Juliana Stein
Brazil 84[2], 91[3], 92, 102, 112[10], 112[12], 141[4], 174, 179[4], 263[2], 264[6], 287, 296
Ko Sui Lan
Hong Kong 263[5]
Gunnar Svanberg
Iceland 127, 285[6], 285[10], 308; Cyprus 114[4], 280
Roland Takeshi
Malaysia 34[4], 166[3], 179[5]
Gurdal Tezvar
Turkey 68[8], 84[3], 188[6]

Suse Uhman
France 52; The Netherlands 70, Italy 85[3], 224, 262[9], Morocco 246
Anders Ulrik
Denmark 33, 260, 289
Erik Undéhn
Sweden 117, 199, 225, 255
Benni Valsson
Iceland 320
Tok Van Vuursen
South Africa 212[2]
Rajesh Vora
India 74[1], 138, 157, 185, 233, 237[2], 238, 274
Suzanne Wales
Malaysia 223
Garth Walker
South Africa 20[6], 75[1], 214, 227, 262[10], 265[6], 285[5]
Krystel Wallet
Canada 54, 141[3], 200, 262[3], 264[7], 303
Guy Wheeler
UK 285[12]
Tyler Whisnand
The Netherlands 107, 112[6], 112[7], 131[3], 131[5], 131[7]
Claudia Wiens
Egypt 166[7], 294[9]
Valerie Williams
Canada 13[3], 68[9], 78, 84[1], 131[4], 160, 166[5], 166[6], 190, 191, 221, 294[2]
Robert Young Pelton
USA 51, 57, 220, 264[2], 265[2]
Kai Zimmerman
Ecuador 38, 91[2], 114[6], 141[2]
Mattias Zoppellaro
Morocco 69[2]

Page/Country/Photographer
Page/Pays/Photographe
Seite/Land/Fotograf